HOW NEW YORK BREAKS YOUR HEART BILL HAYES

HOW NEW YORK BREAKS YOUR HEART

BILL HAYES

BLOOMSBURY

NEW YORK · LONDON · OXFORD · NEW DELHI · SYDNEY

Bloomsbury USA
An imprint of Bloomsbury Publishing Plc

1385 Broadway 50 Bedford Square
New York London
NY 10018 WC1B 3DP
USA UK

www.bloomsbury.com

BLOOMSBURY and the Diana logo are trademarks of Bloomsbury Publishing Plc

First published 2018
© Bill Hayes, 2018

ISBN: HB: 978-1-63557-085-4
ePub: 978-1-63557-086-1

LIBRARY OF CONGRESS CATALOGING-IN-PUBLICATION DATA

Names: Hayes, Bill, photographer, writer of added text.
Title: How New York breaks your heart / Bill Hayes.
Description: New York : Bloomsbury USA, An imprint of Bloomsbury Publishing Plc, 2018.
Identifiers: LCCN 2017017262 | ISBN 9781635570854 (hardcover : alk. paper)
Subjects: LCSH: Street photography—New York (State)—New York. | New York (N.Y.)—Pictorial works.
Classification: LCC TR659.8 .H39 2018 | DDC 779/.4097471—dc23 LC
record available at https://lccn.loc.gov/2017017262

2 4 6 8 10 9 7 5 3 1

Designed by Patti Ratchford
Printed and bound by RR Donnelly Asia Printing Solutions Limited

To find out more about our authors and books visit www.bloomsbury.com. Here you will find extracts, author interviews, details of forthcoming events and the option to sign up for our newsletters.

Bloomsbury books may be purchased for business or promotional use. For information on bulk purchases please contact Macmillan Corporate and Premium Sales Department at specialmarkets@macmillan.com.

For Emily Forland

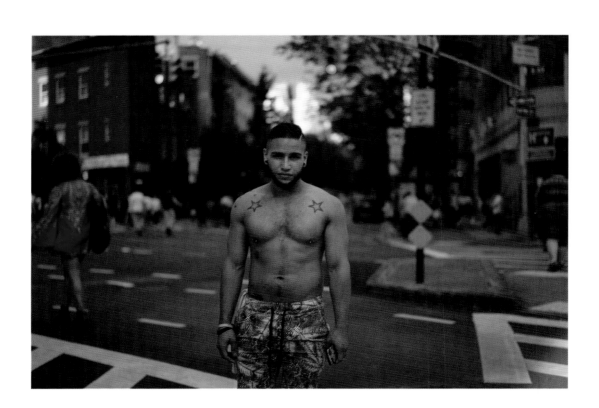

How New York breaks your heart

First, it lets you fall in love with it.

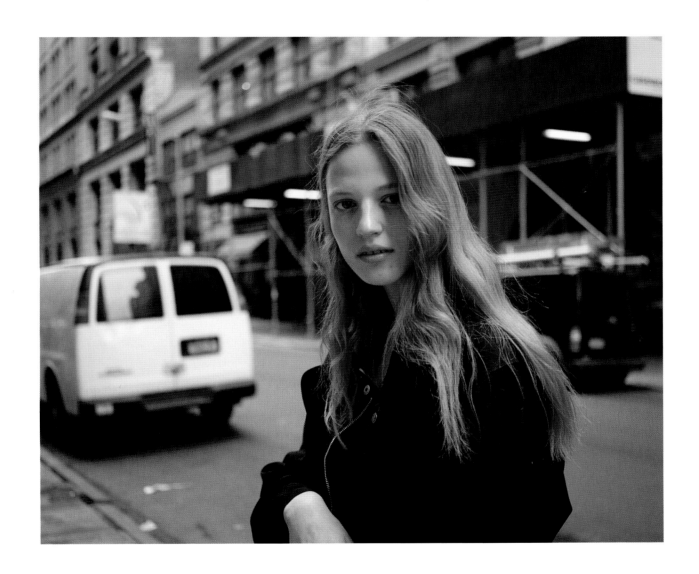

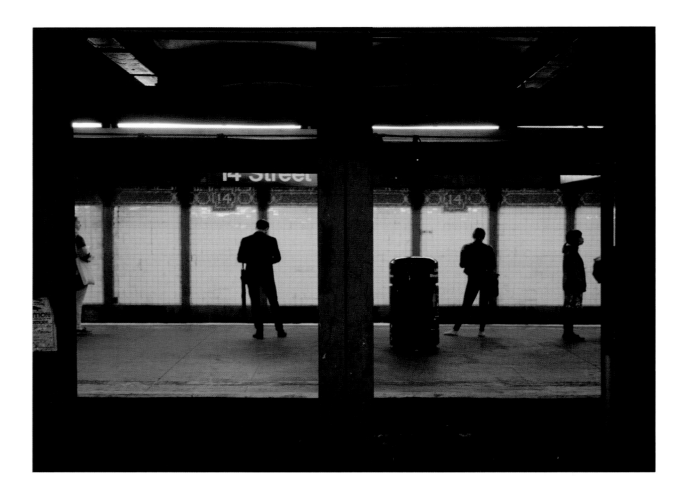

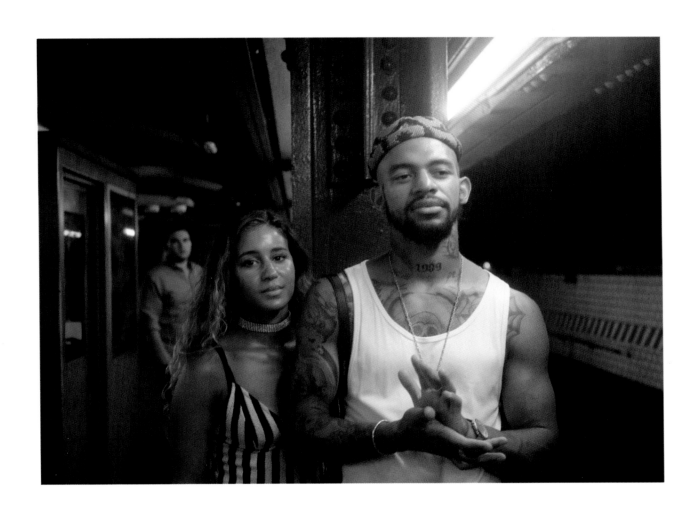

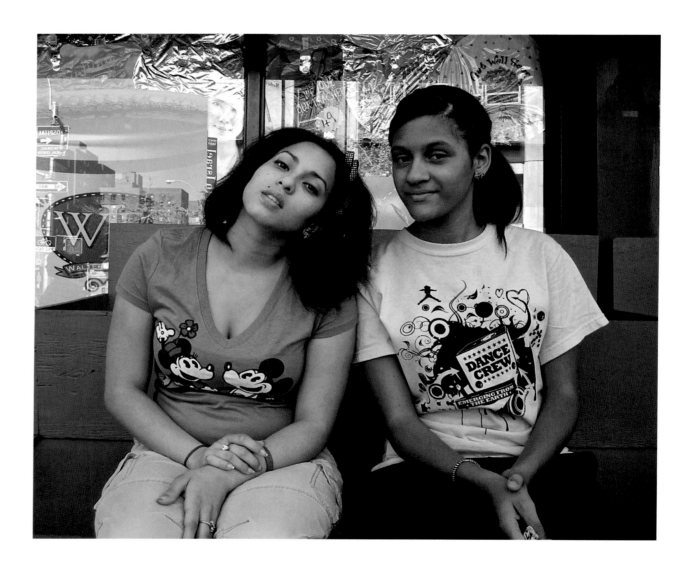

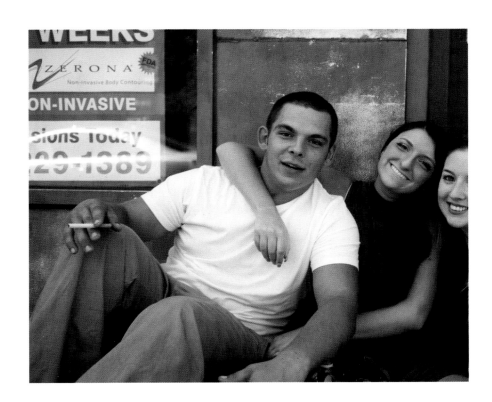

And lets you think it loves you back.

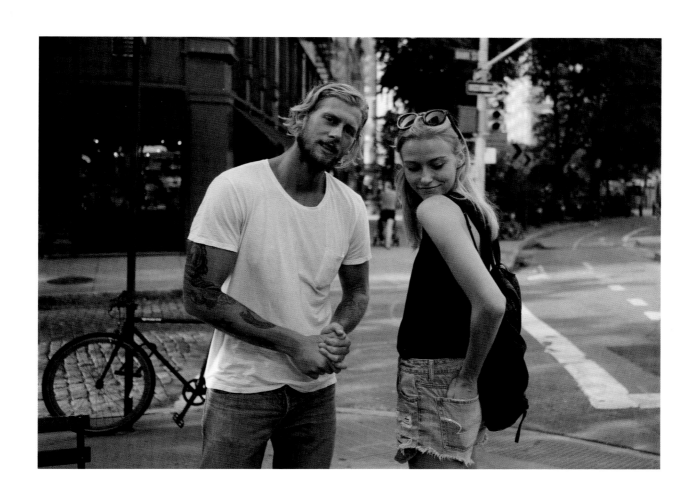

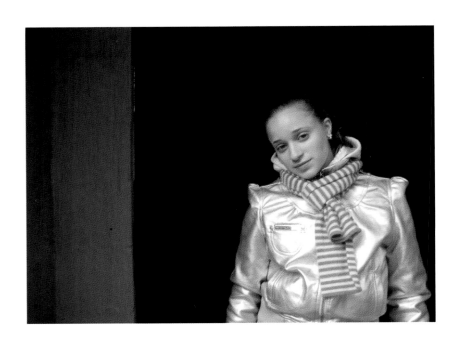

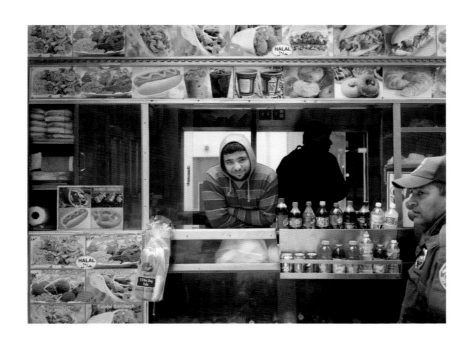

You begin to forget the sorrow that brought you to New York in the first place . . .

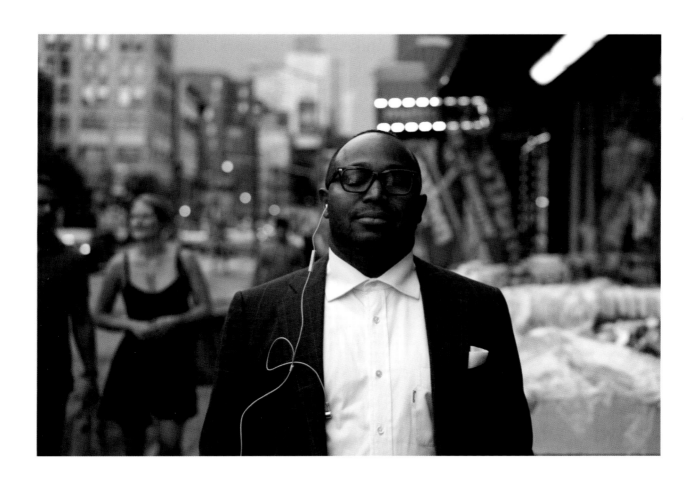

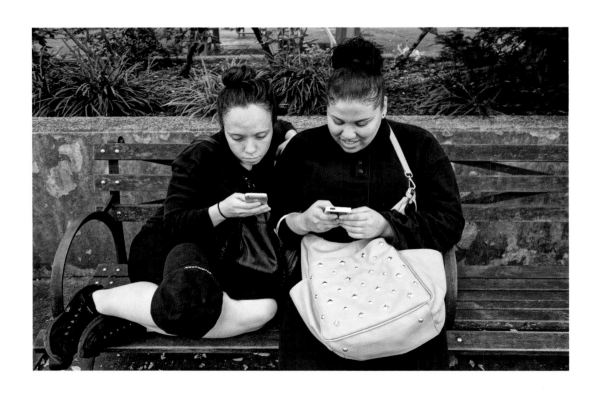

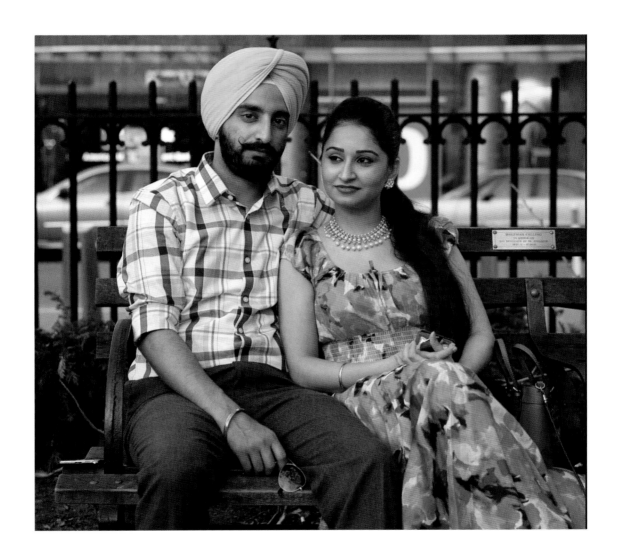

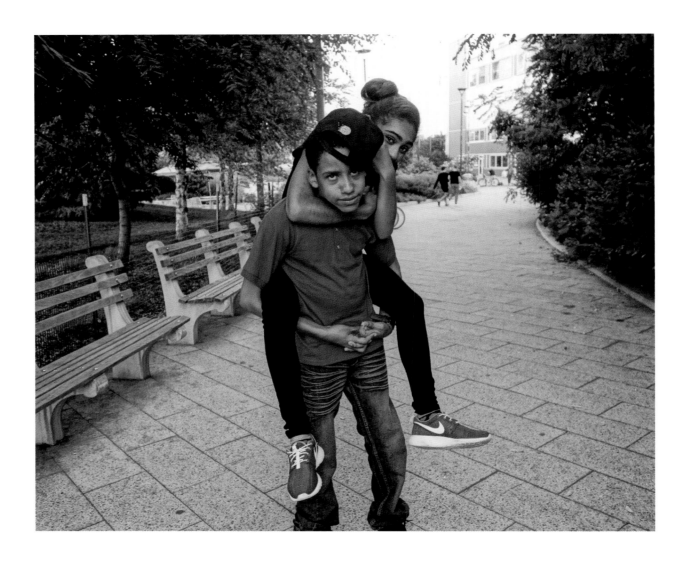

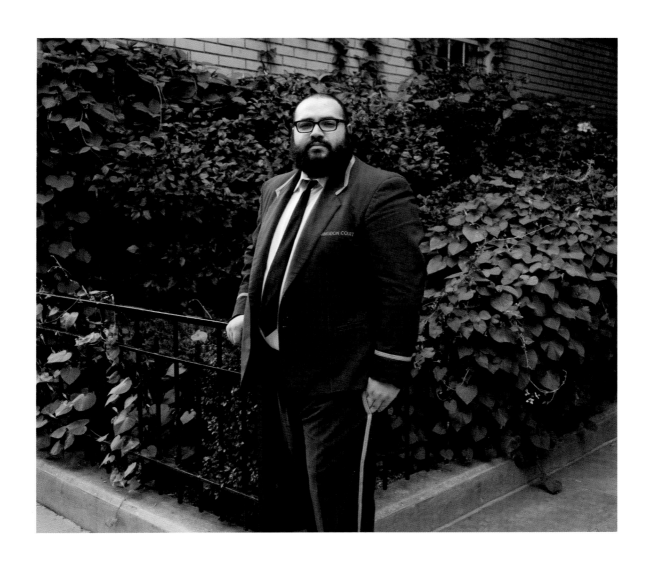

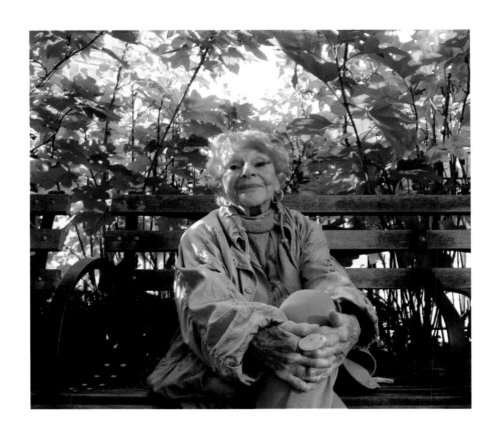

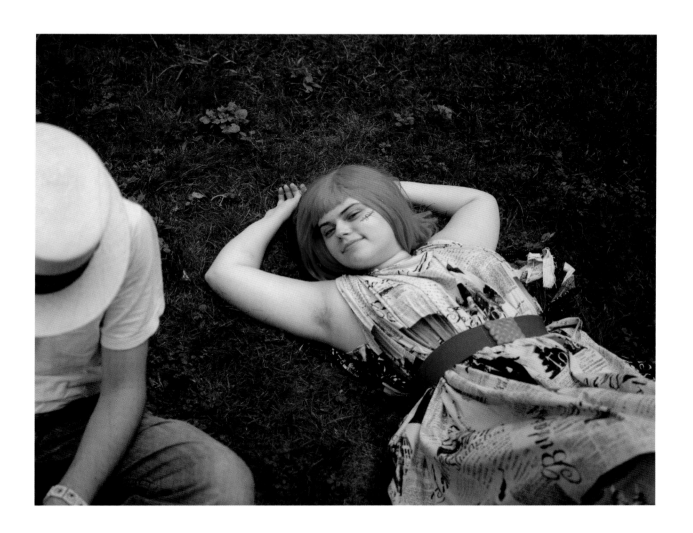

. . . and the love you feel for the city becomes the love you have for another man.

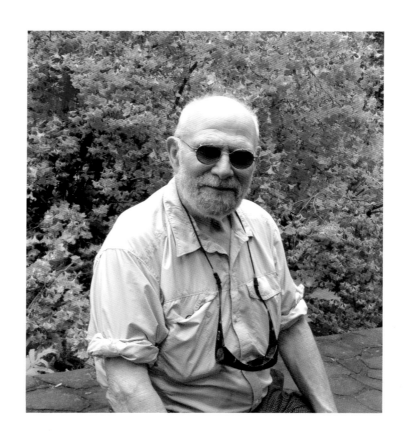

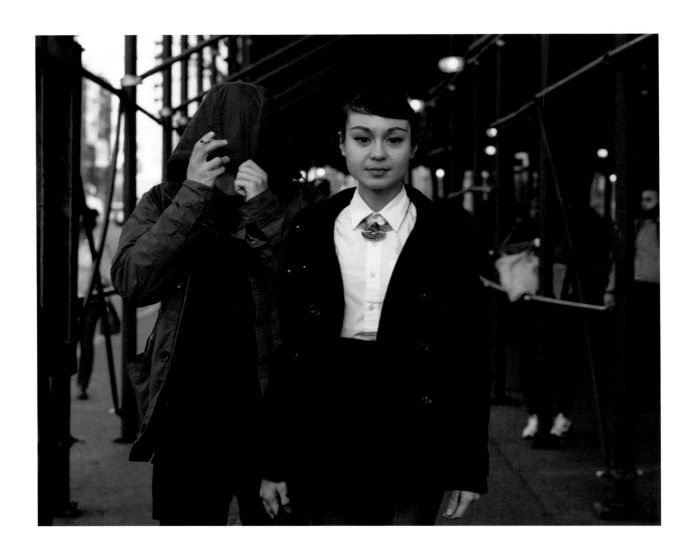

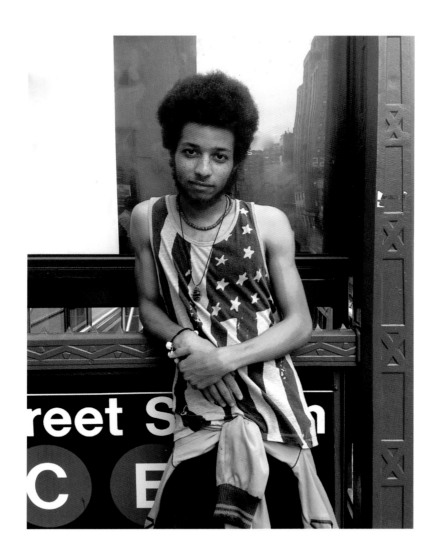

But then, when he is taken from you late one summer night,
there is New York—right there, right outside your window . . .

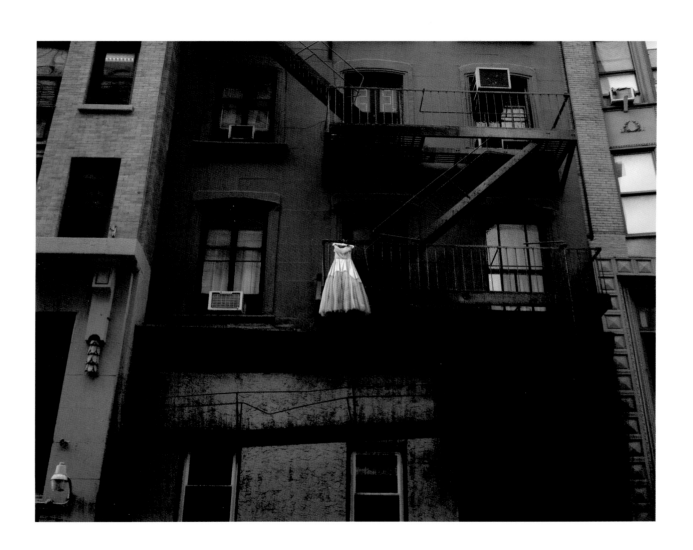

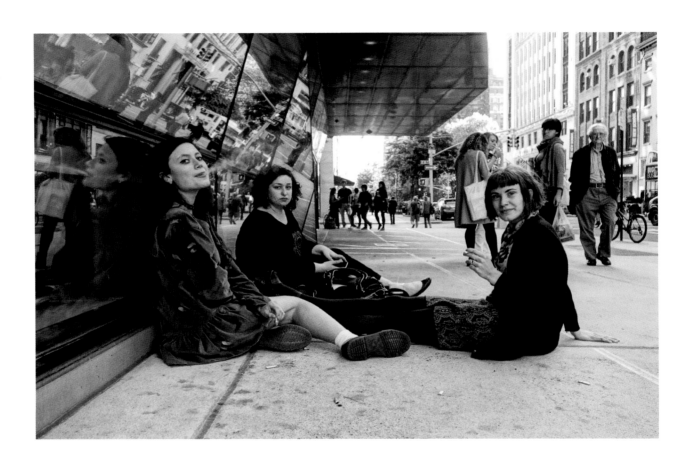

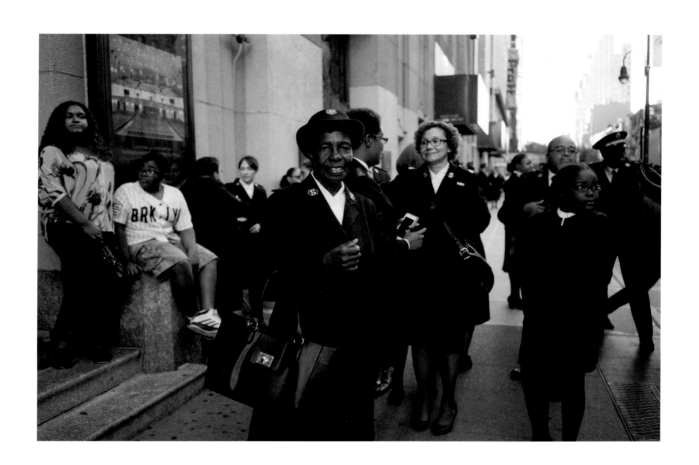

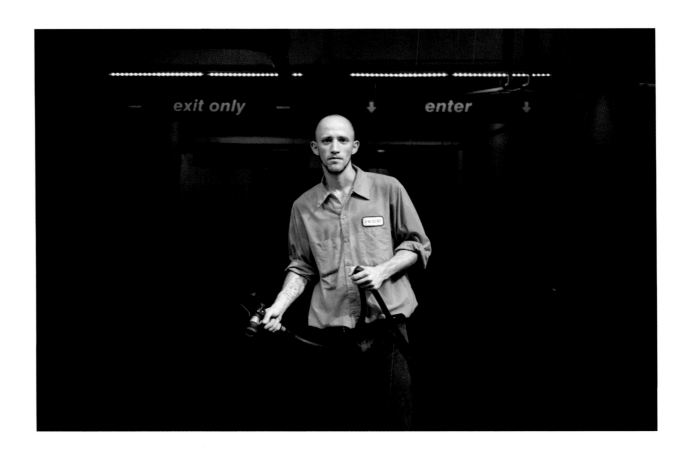

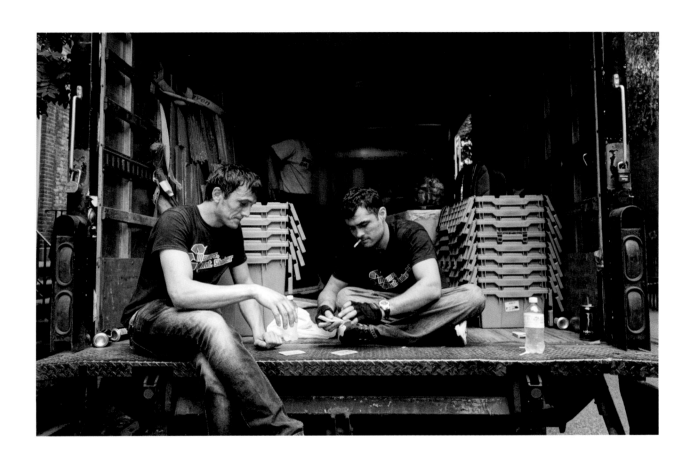

. . . and there are New Yorkers—on the street, on the sidewalk, on the way to wherever you are headed next.

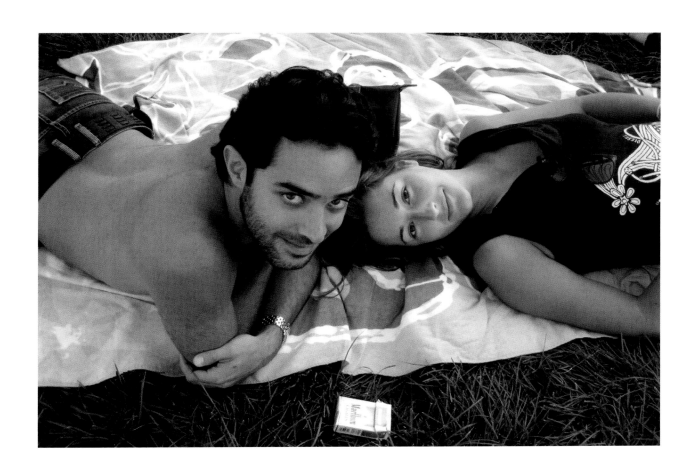

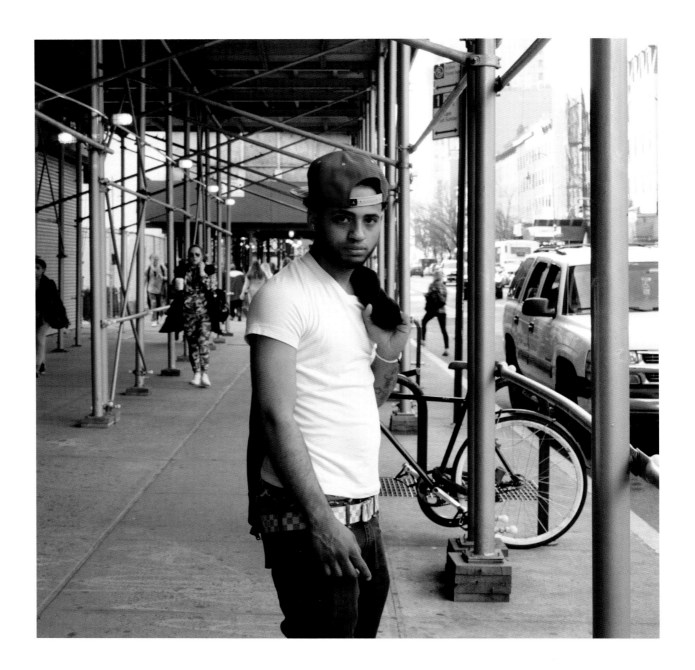

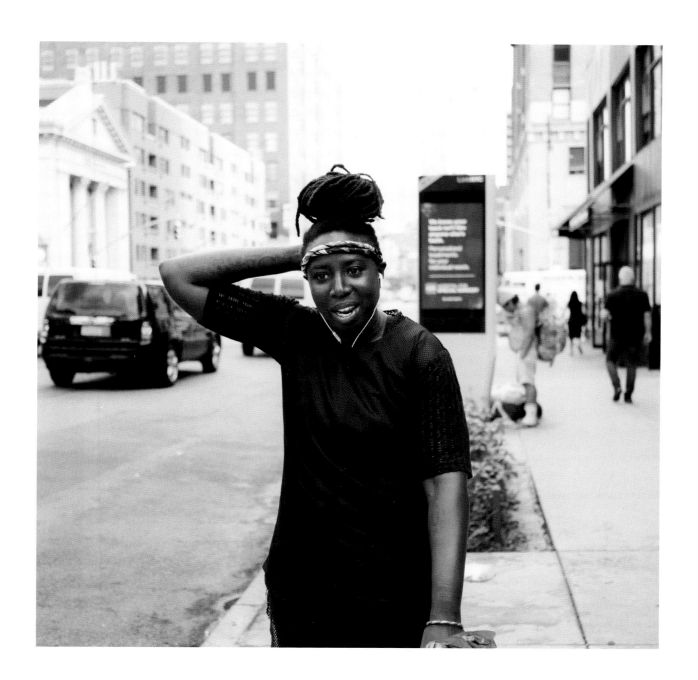

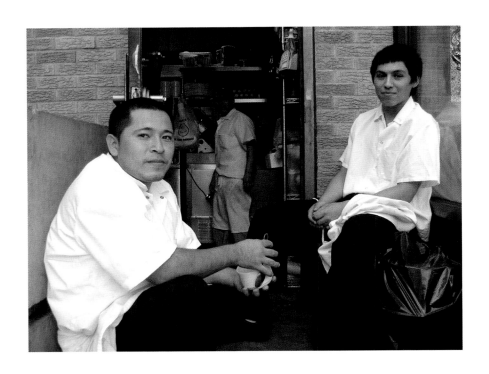

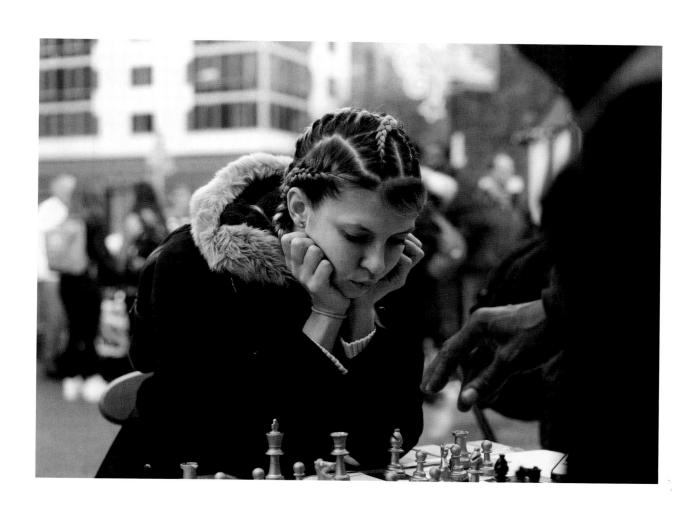

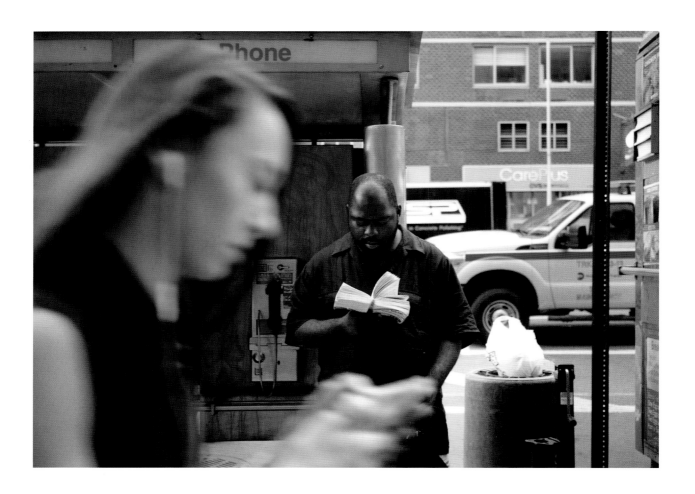

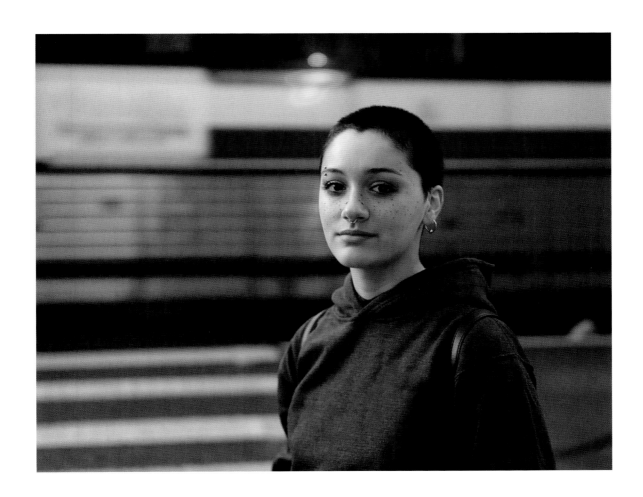

"Can I take your picture?" you sometimes ask.

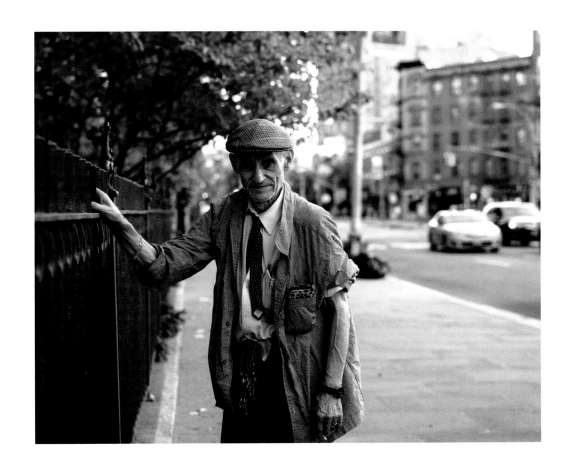

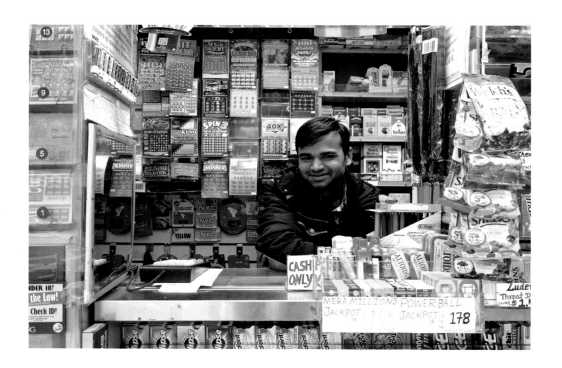

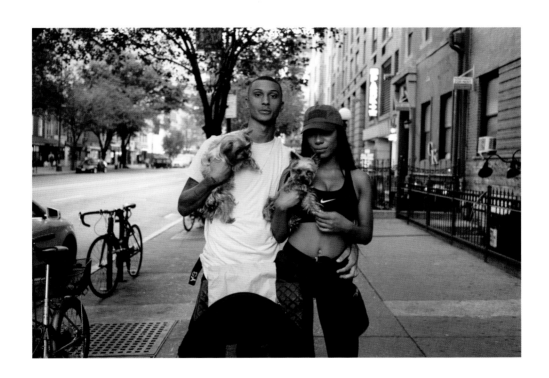

And more often than not, they say yes.

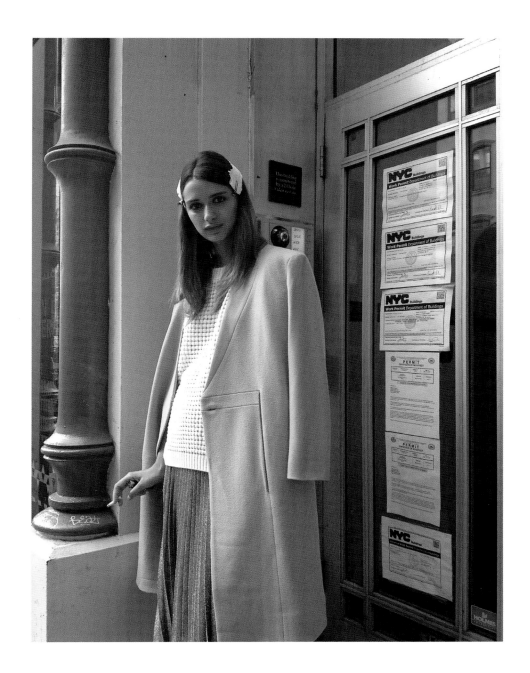

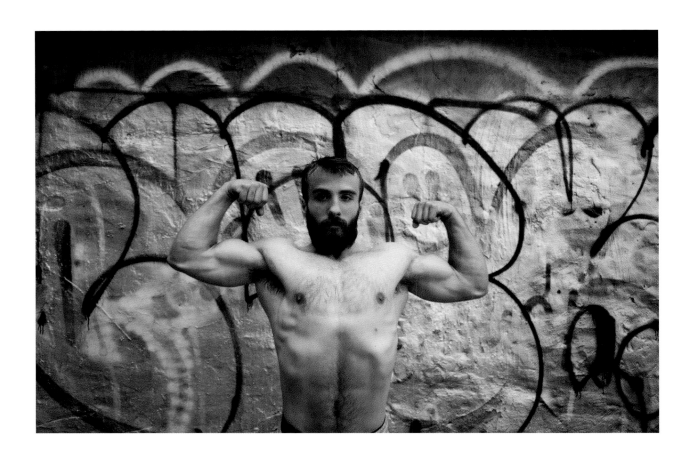

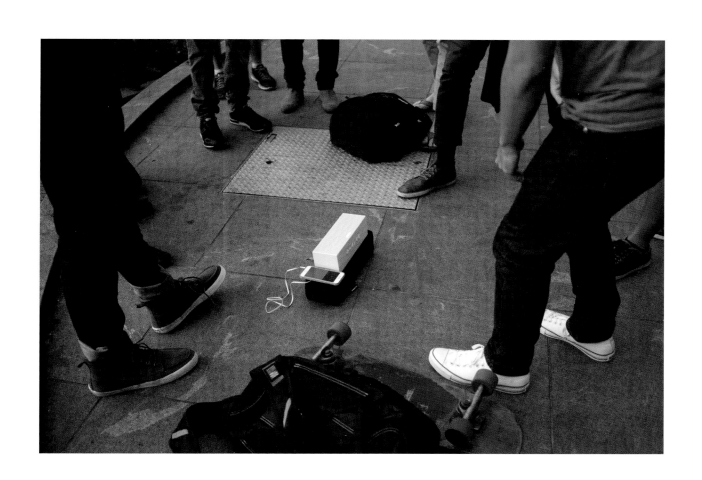

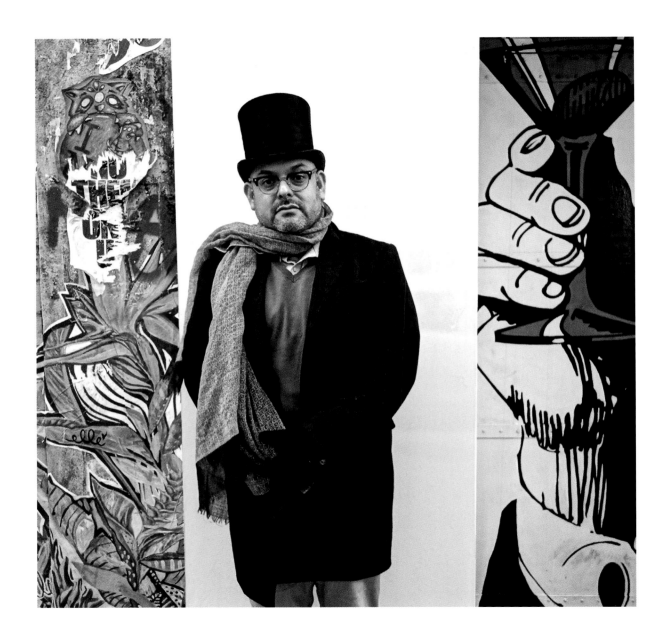

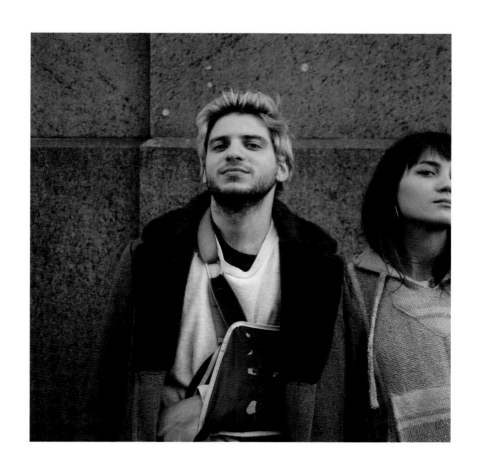

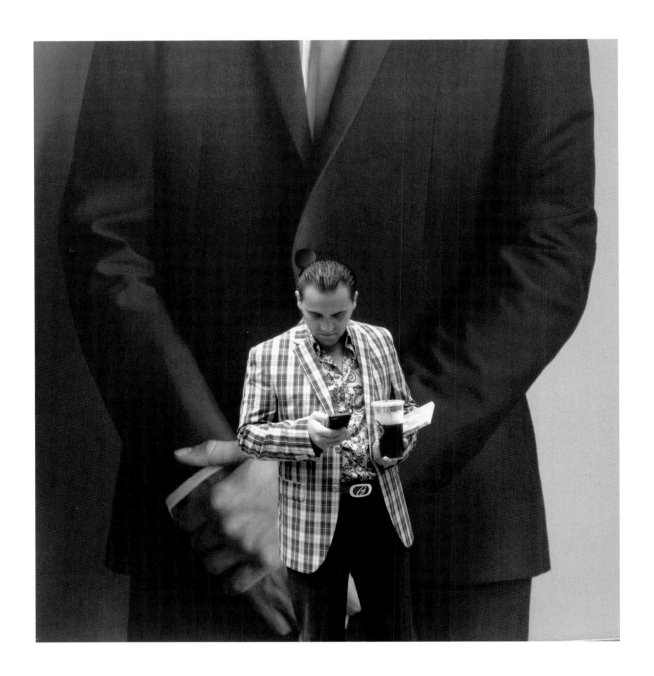

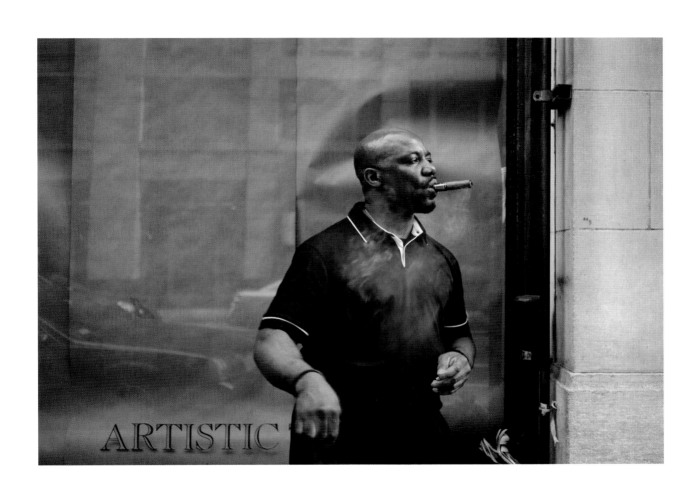

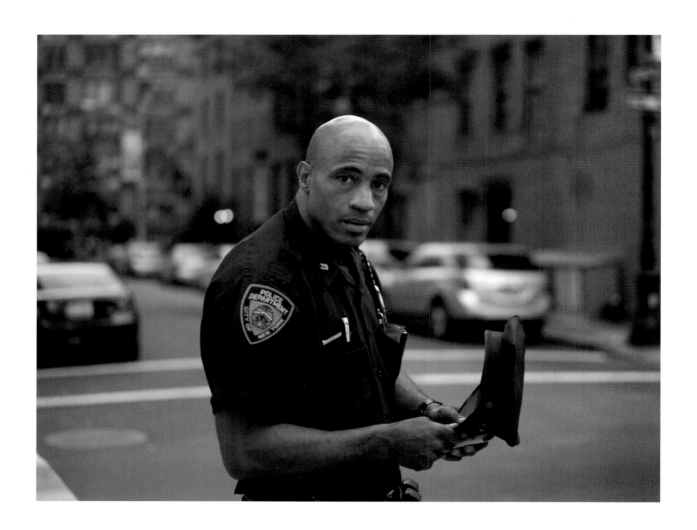

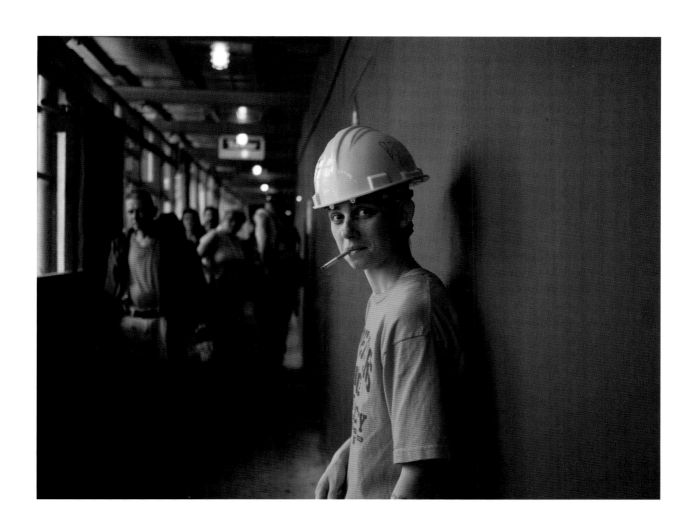

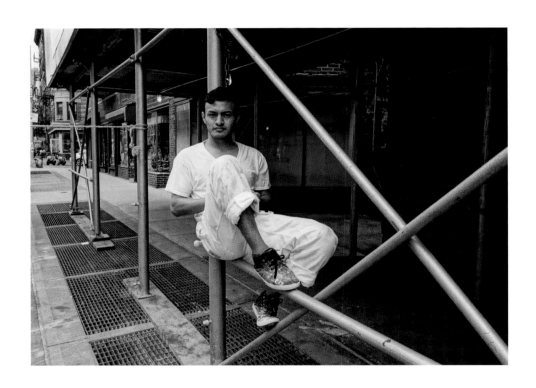

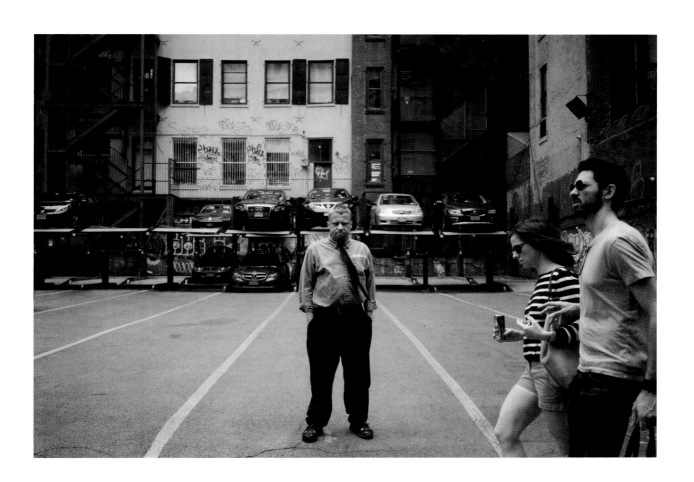

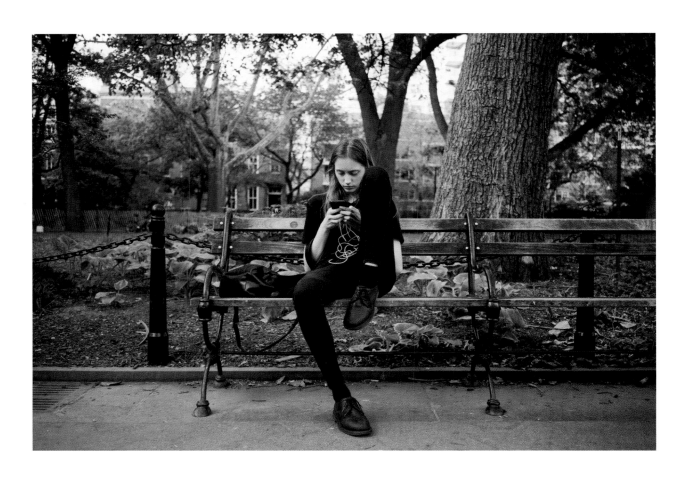

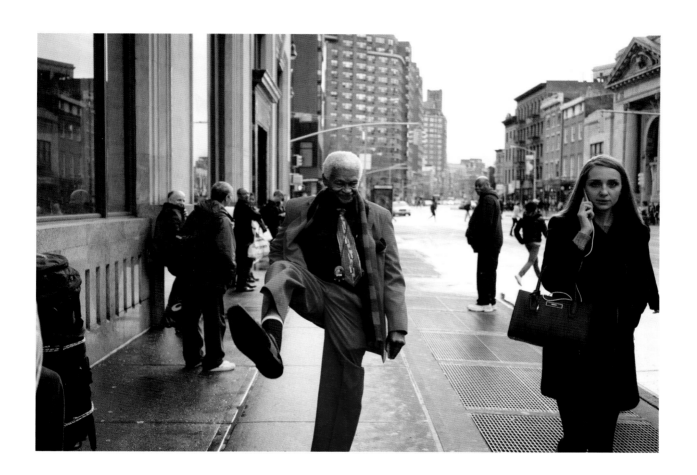

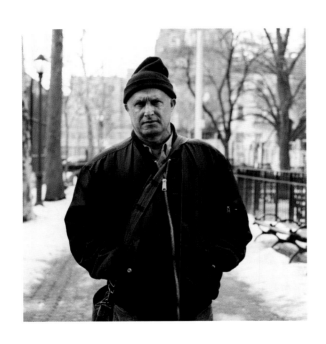 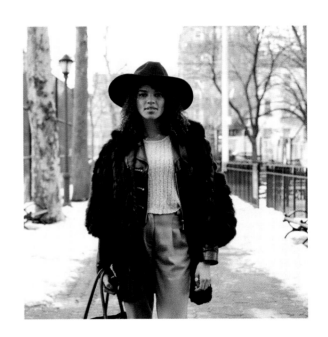

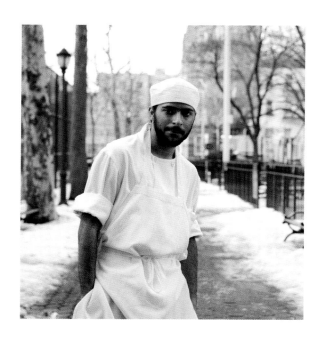

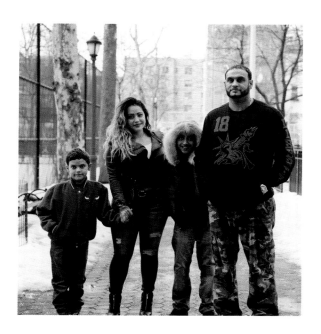

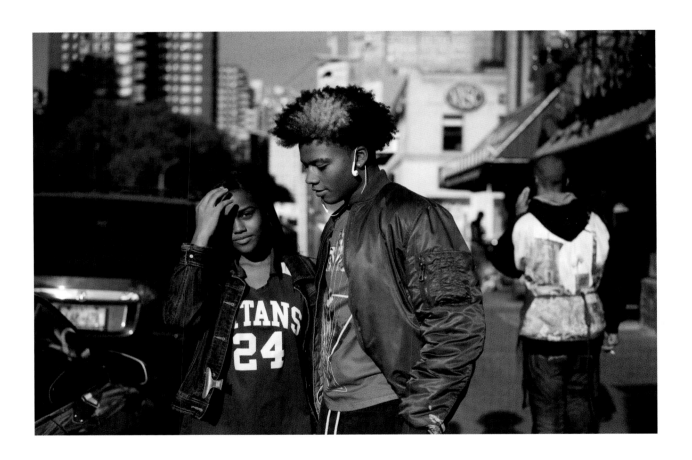

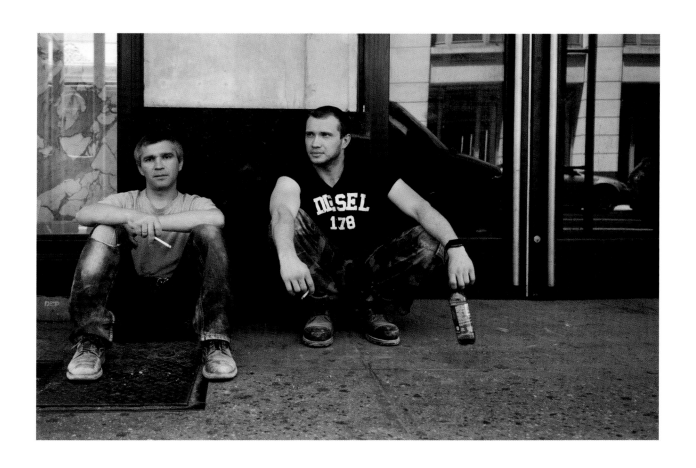

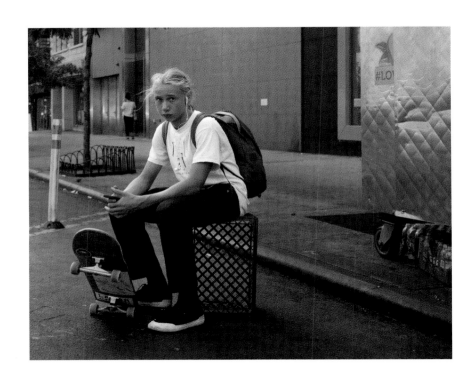

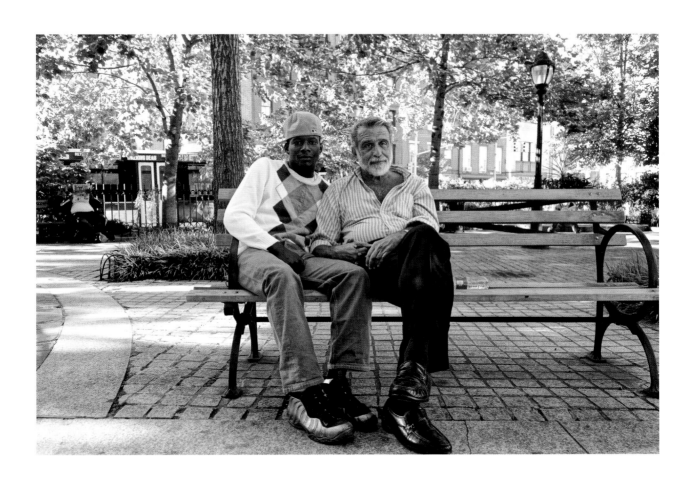

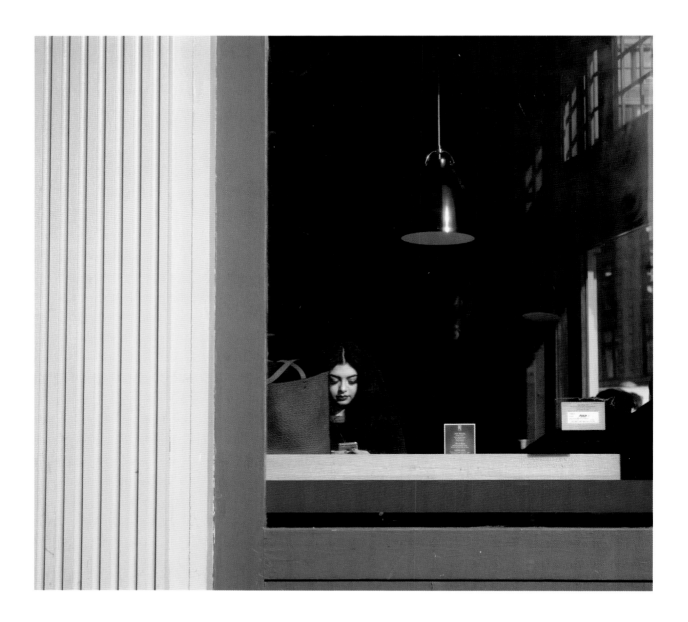

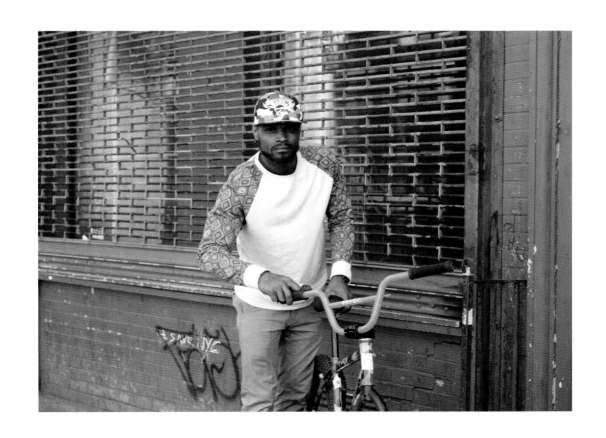

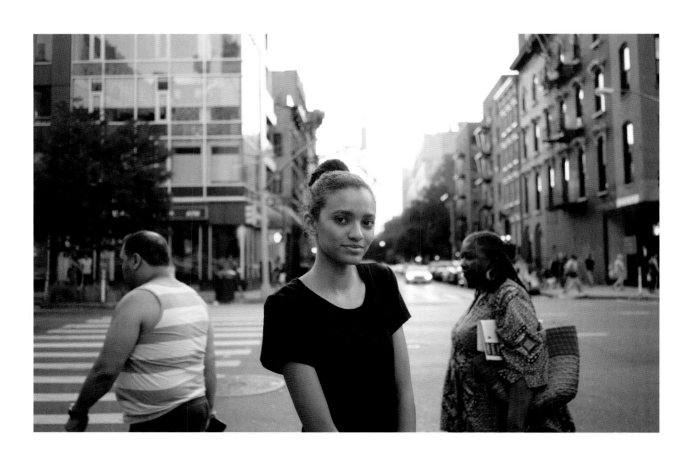

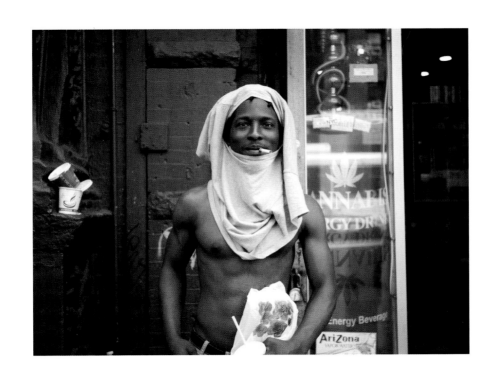

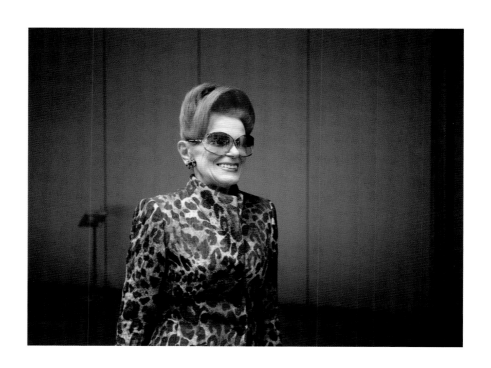

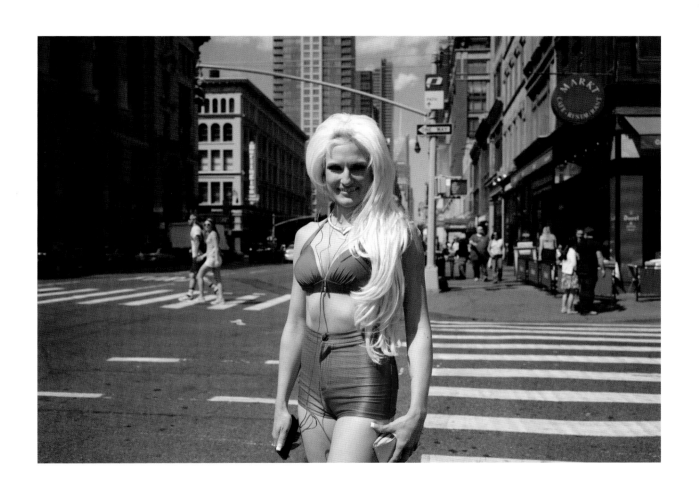

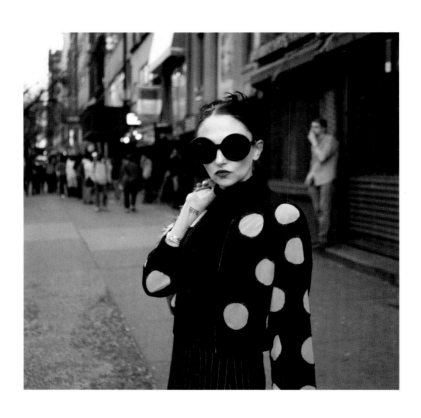

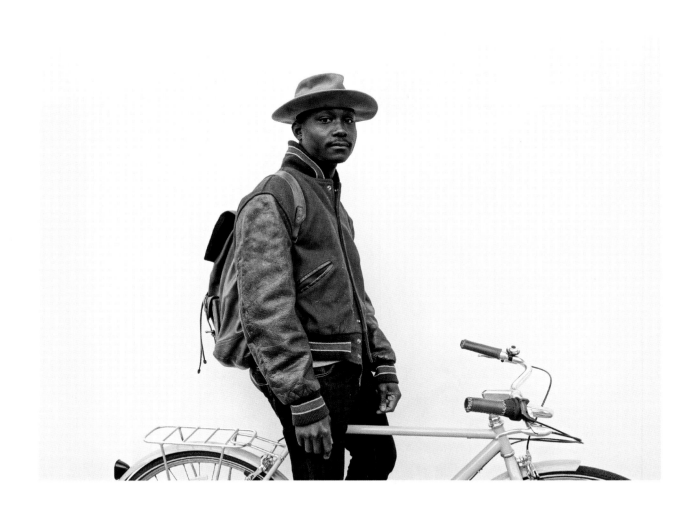

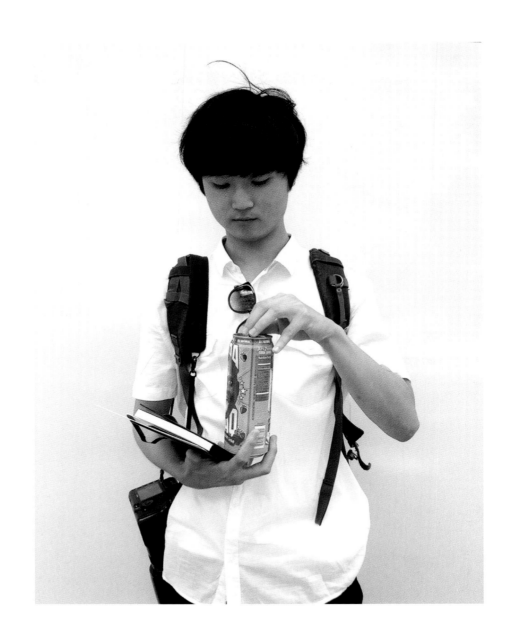

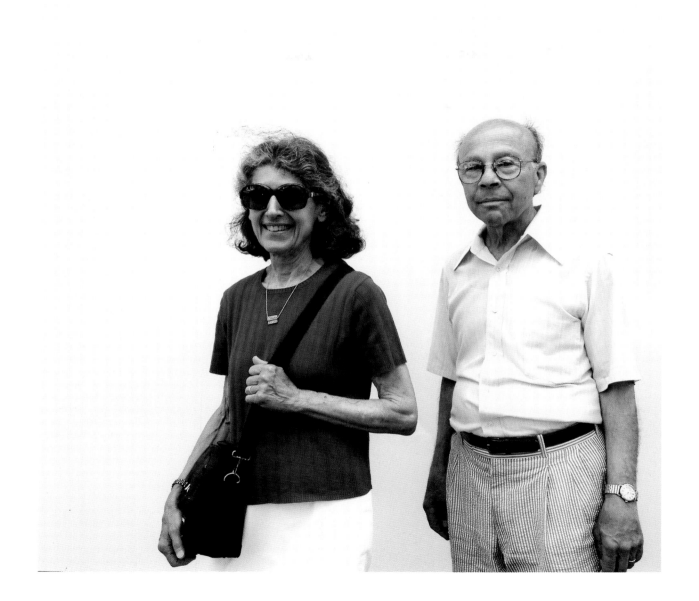

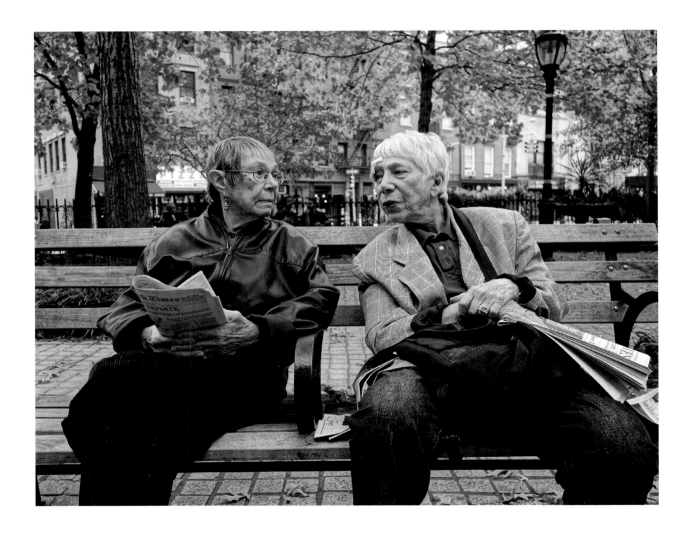

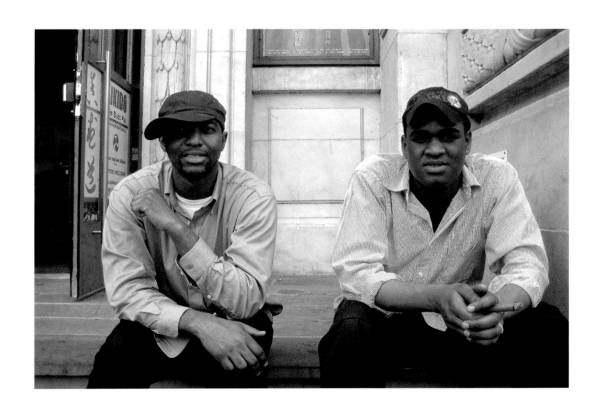

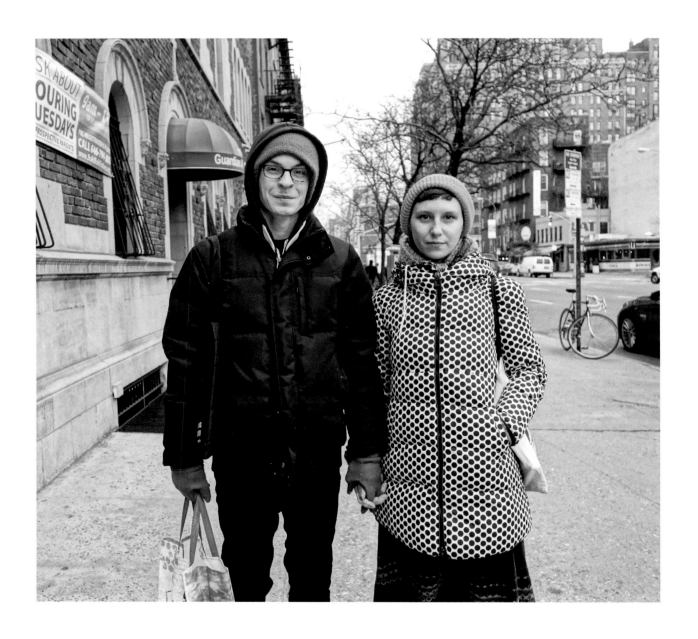

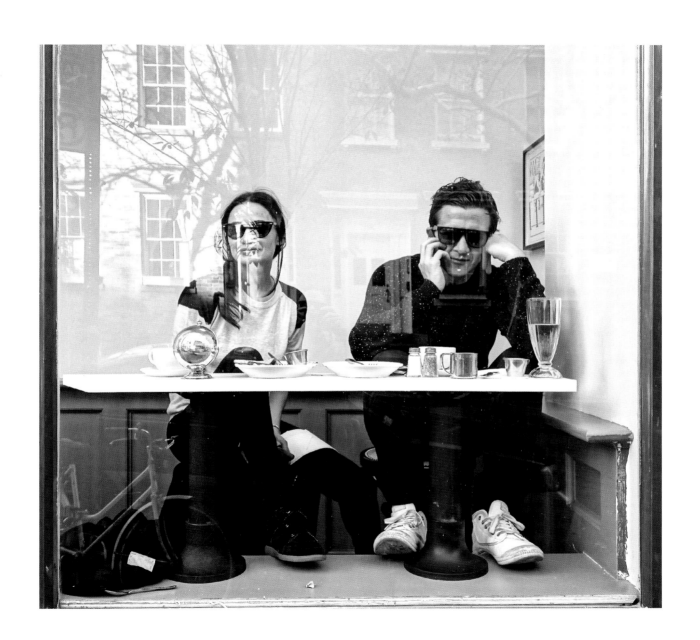

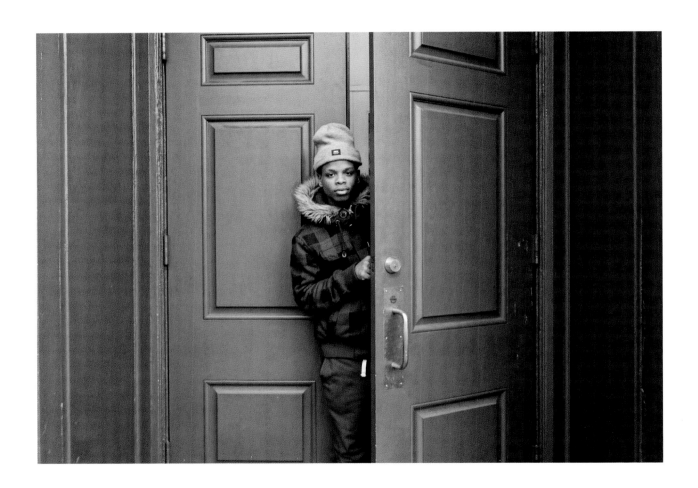

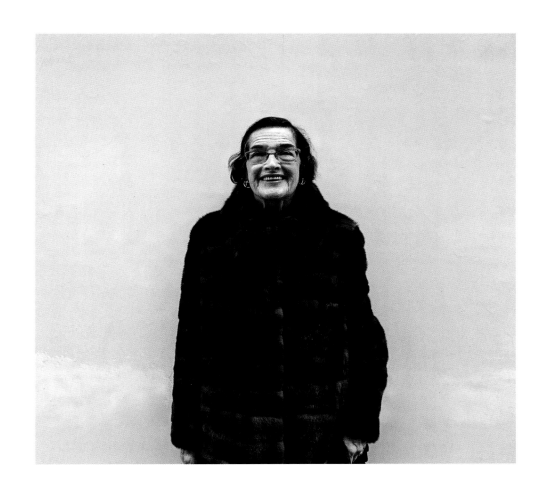

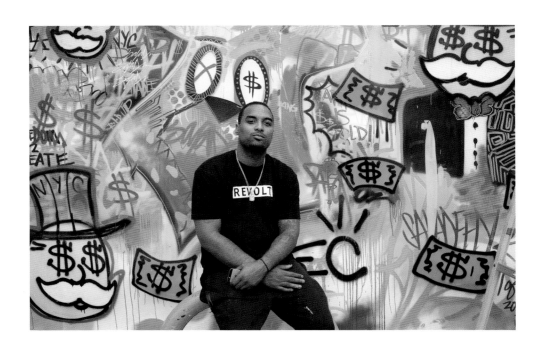

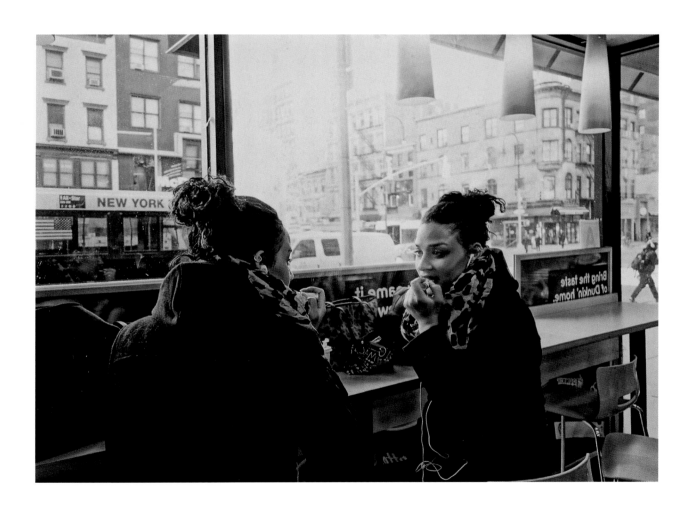

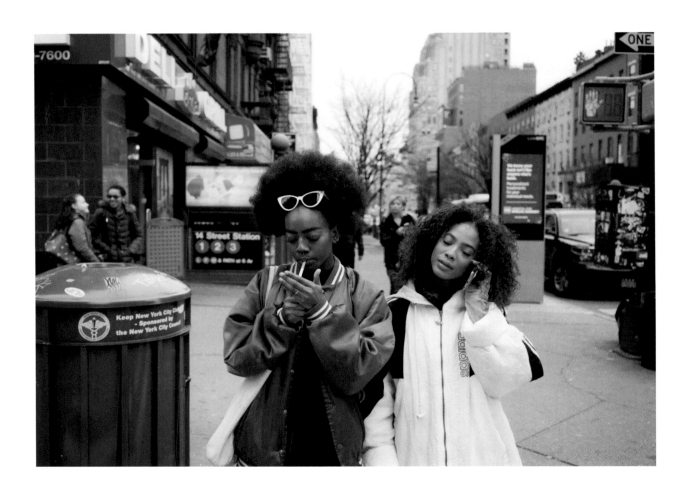

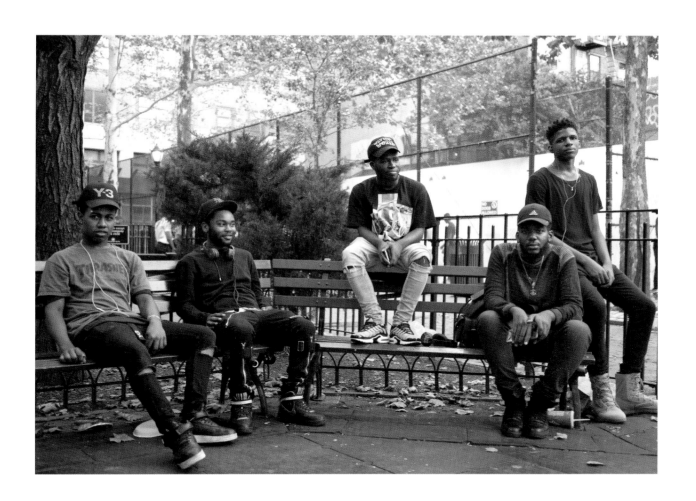

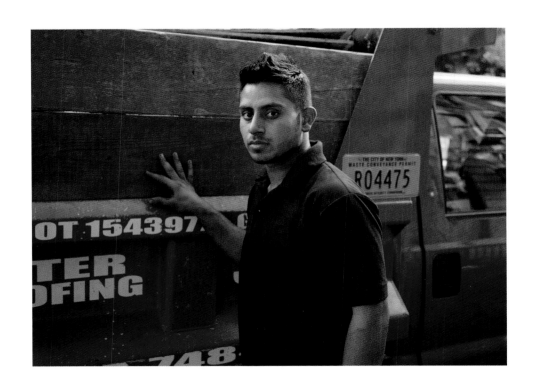

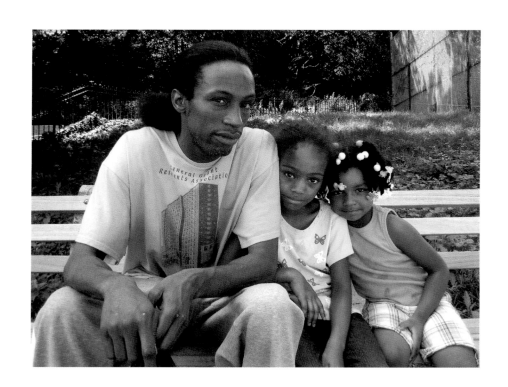

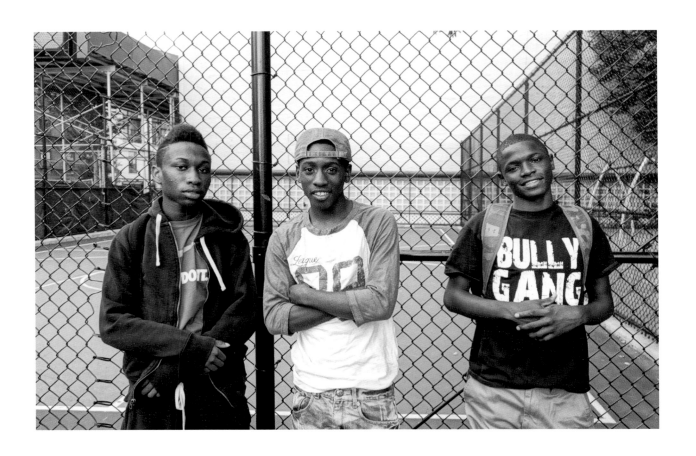

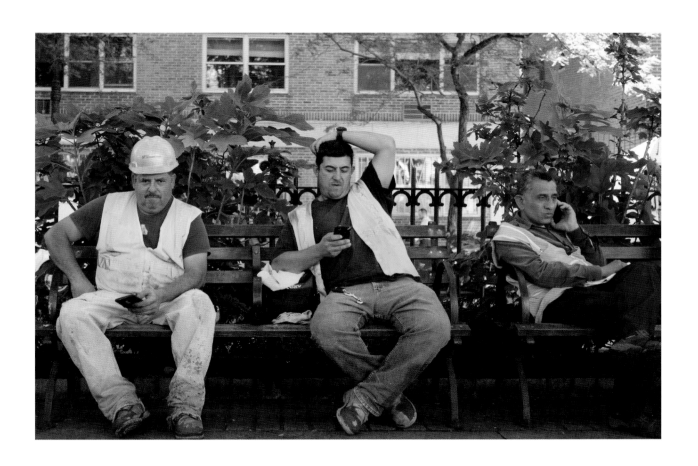

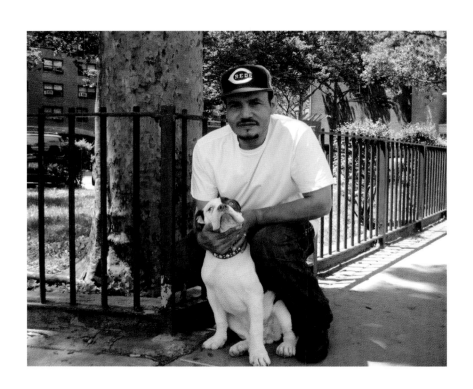

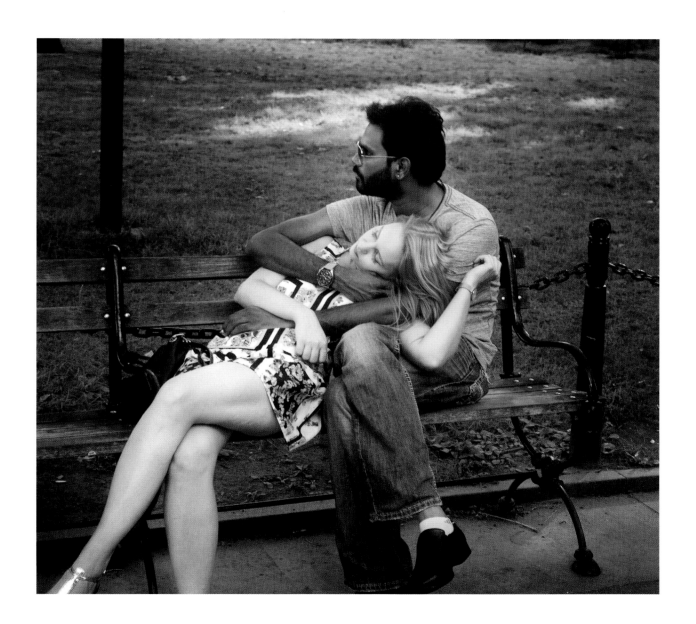

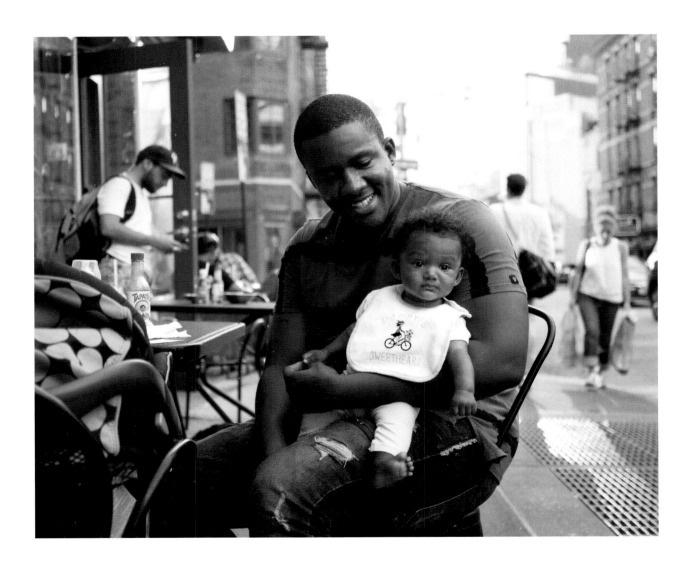

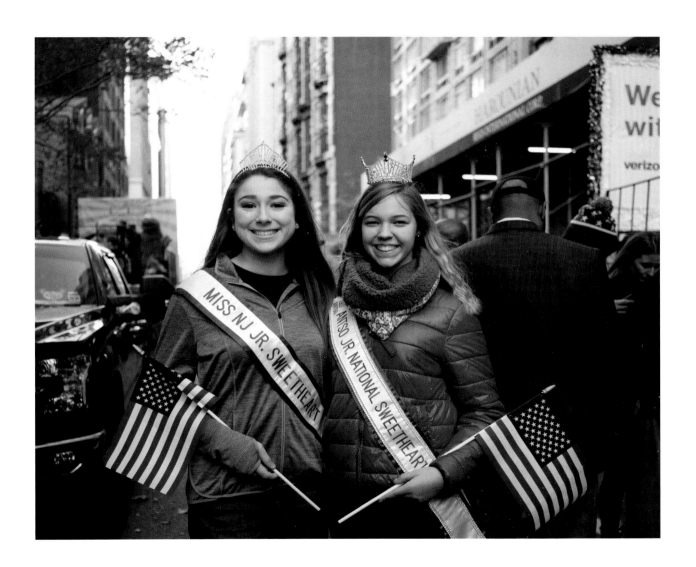

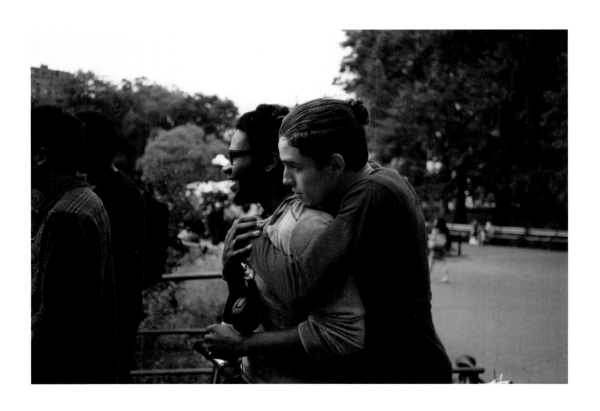

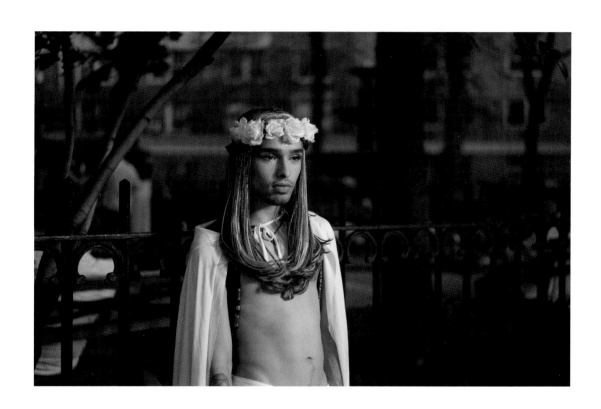

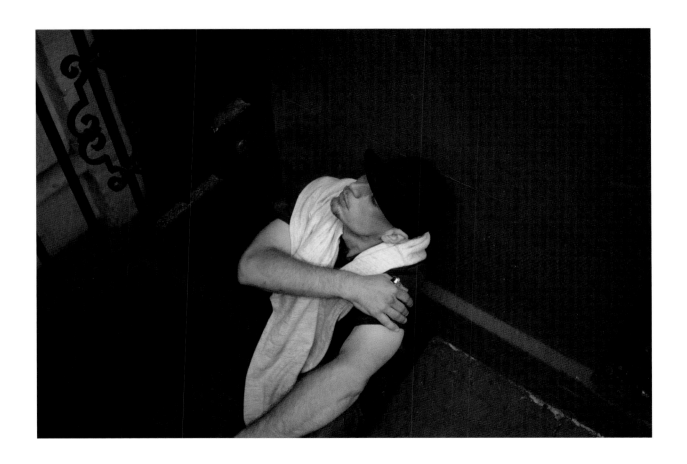

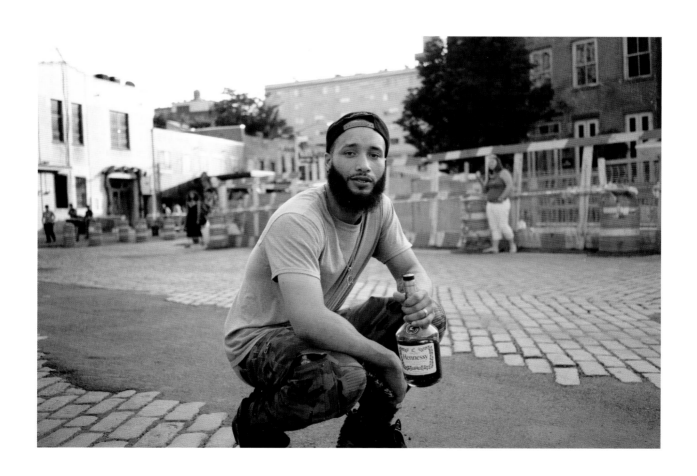

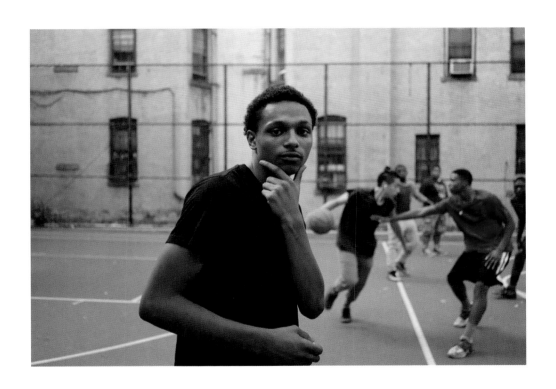

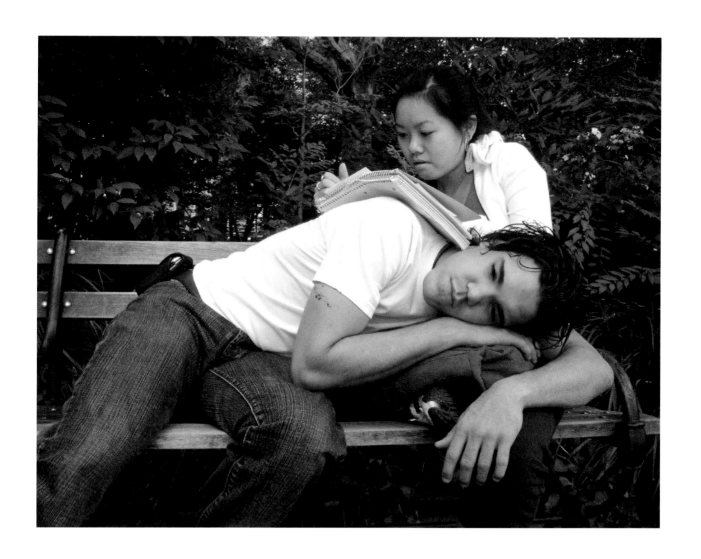

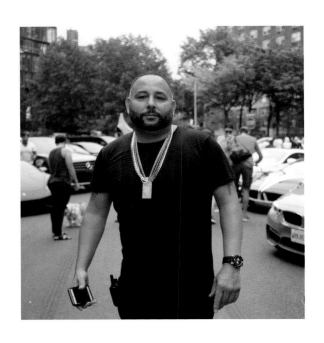
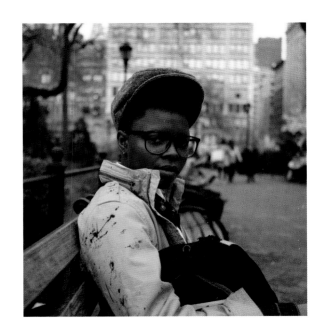

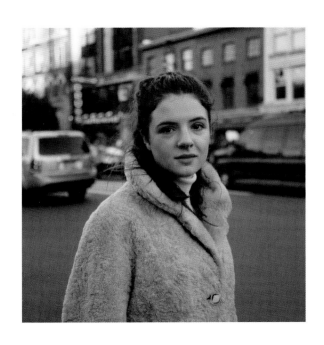

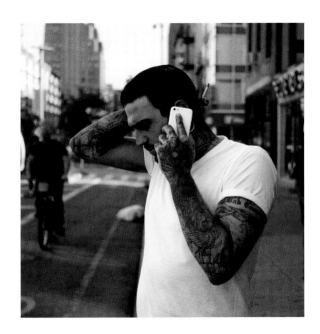

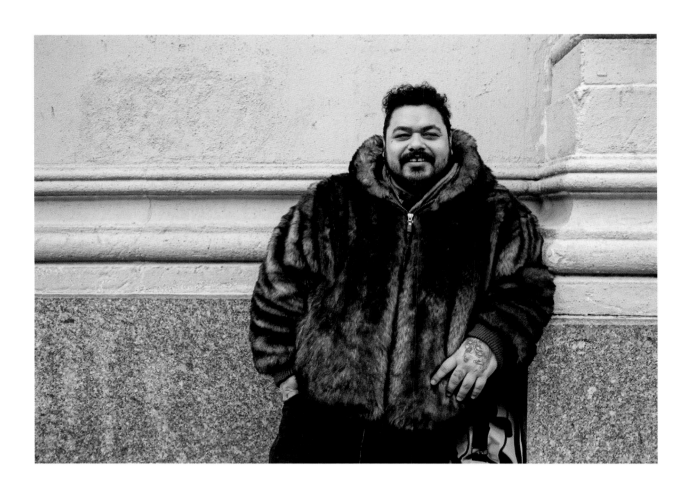

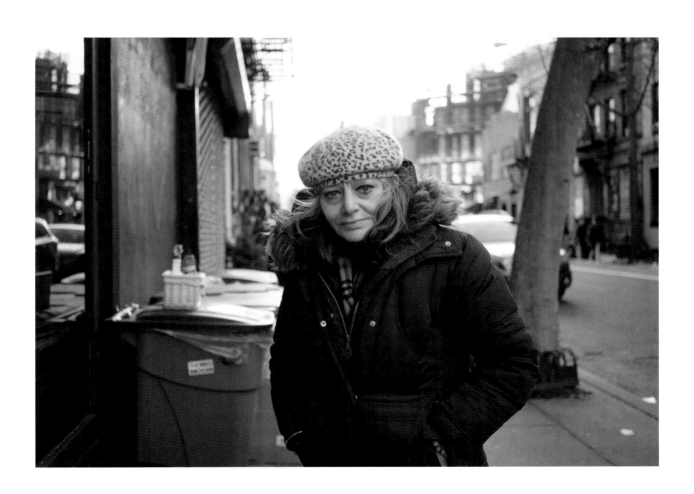

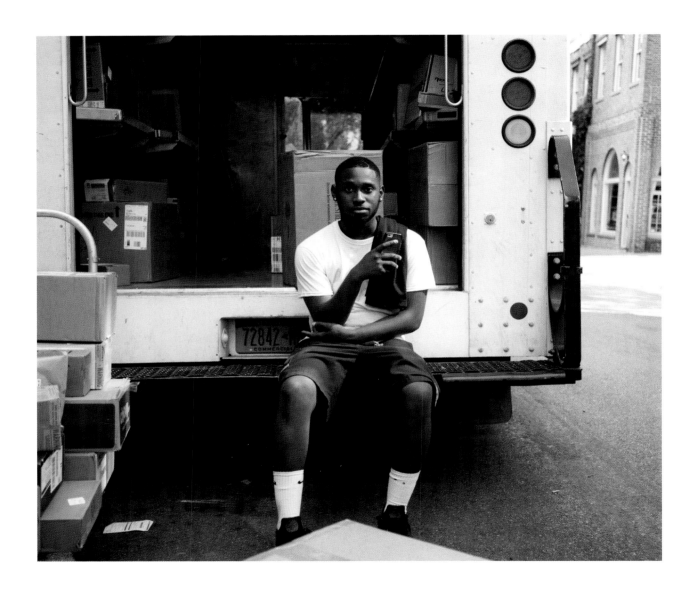

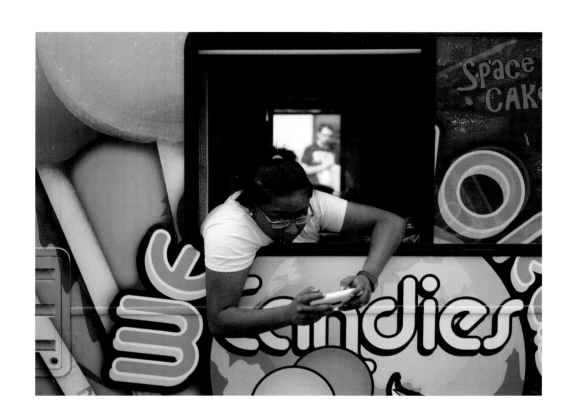

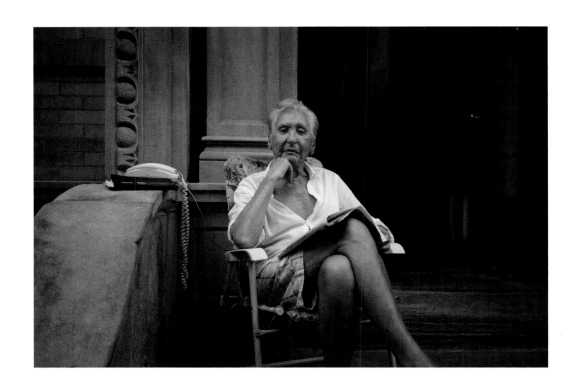

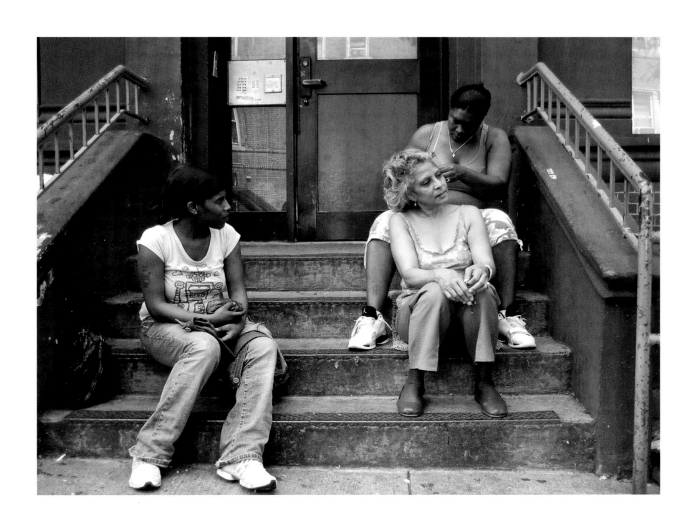

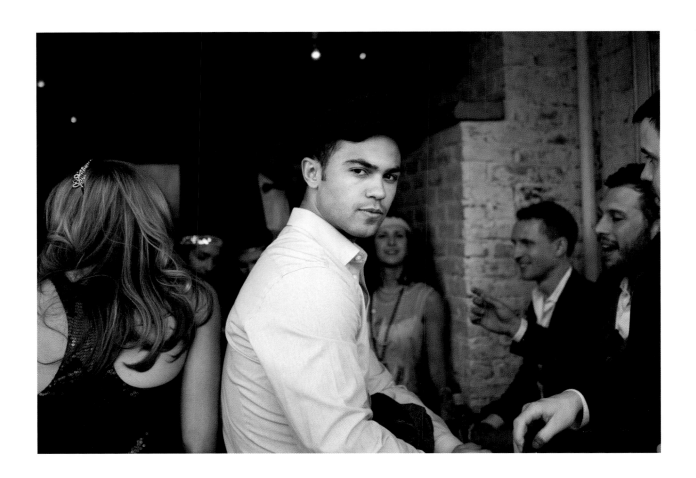

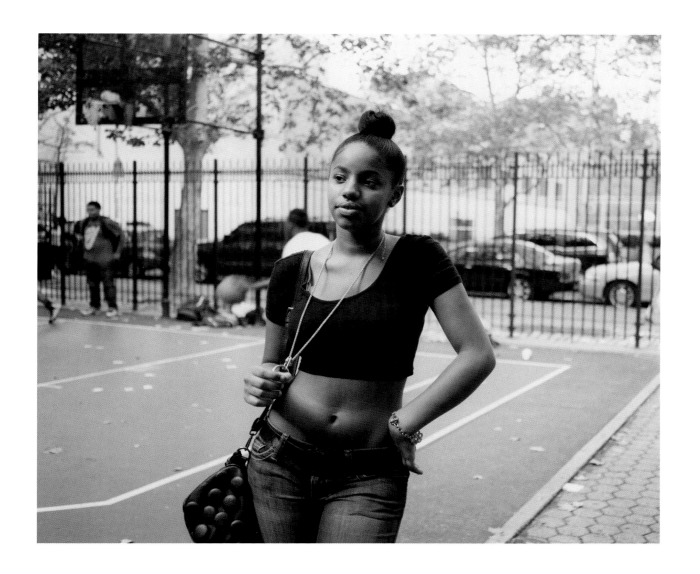

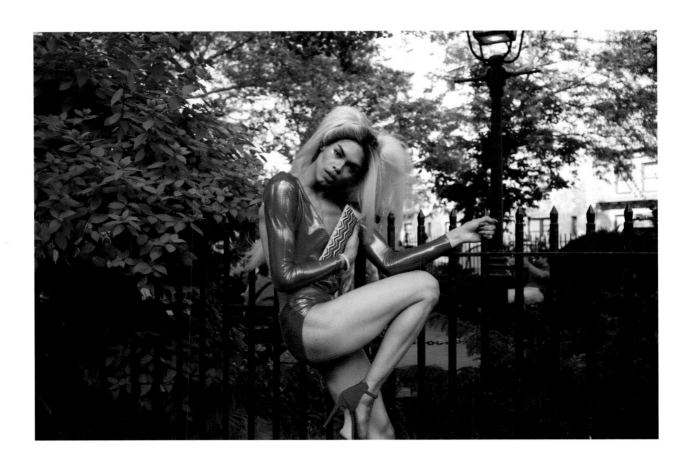

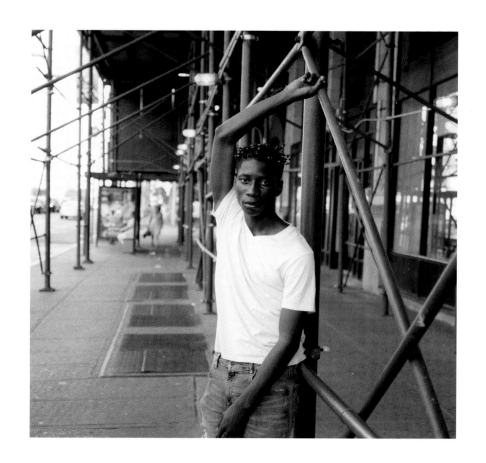

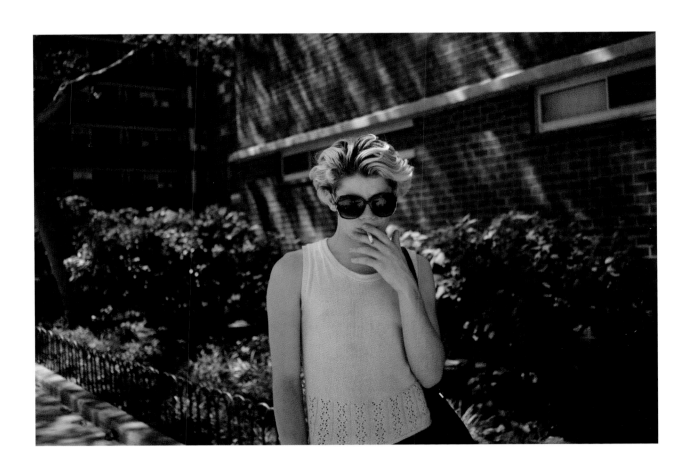

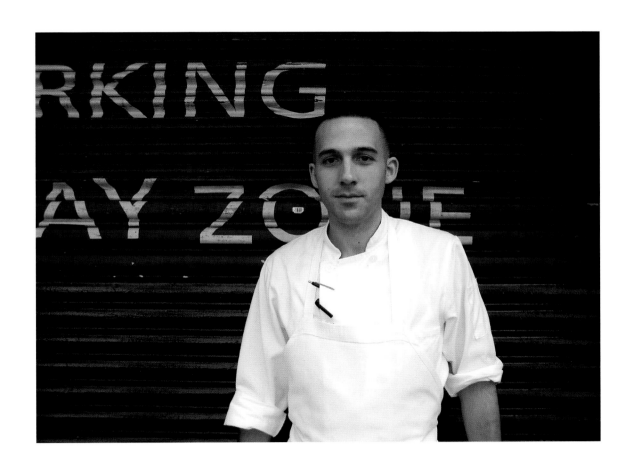

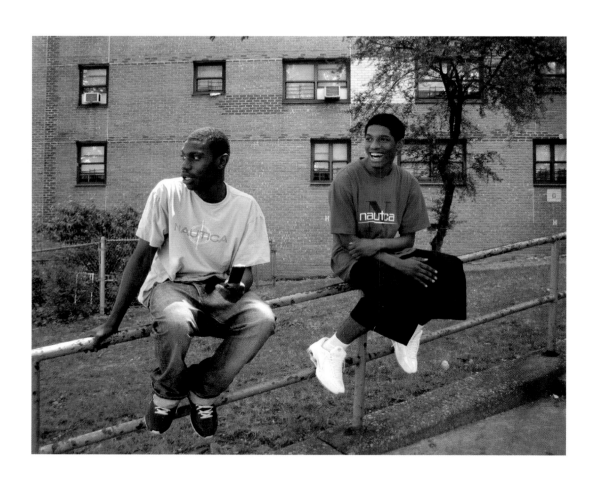

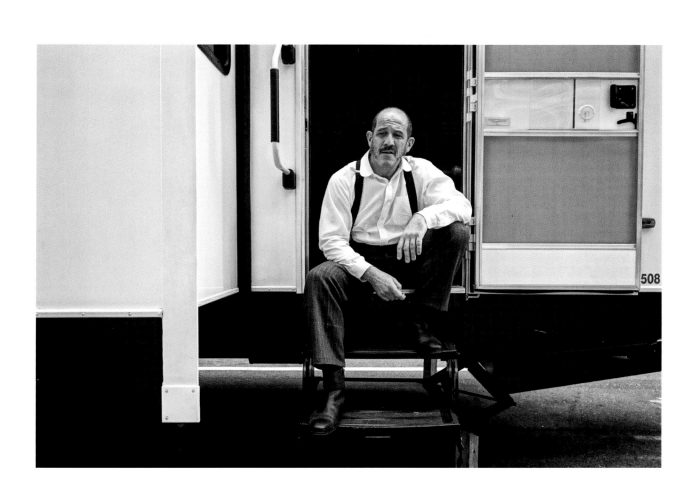

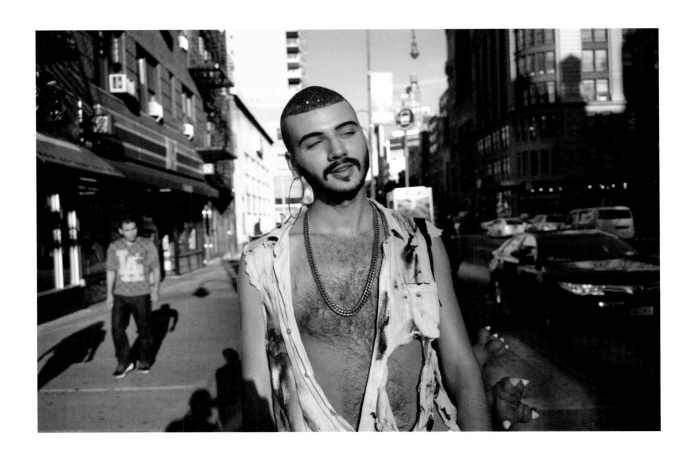

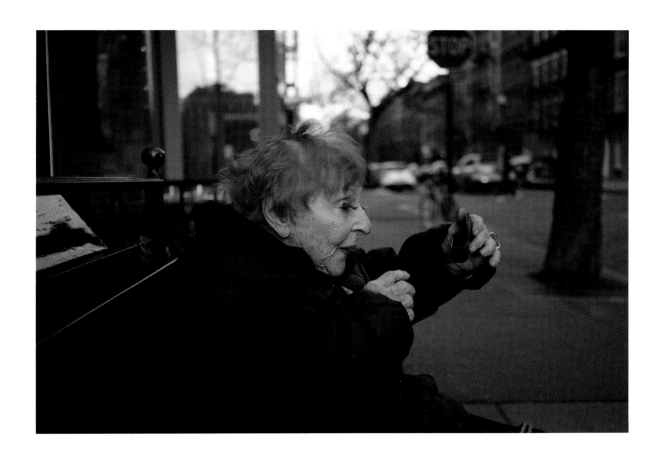

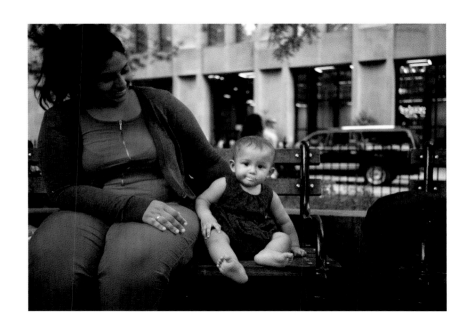

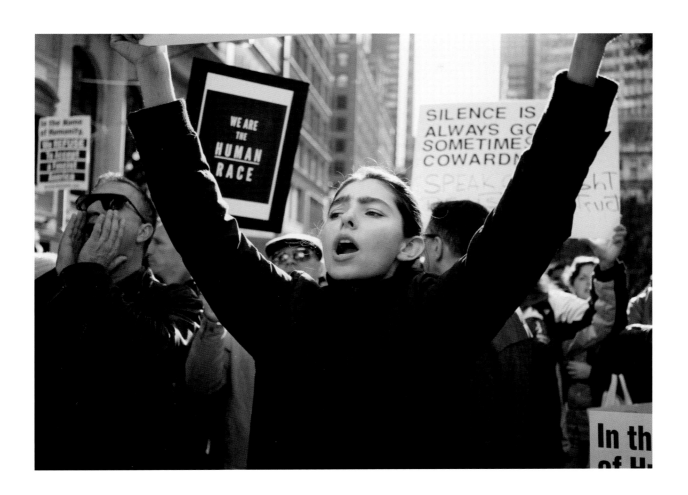

Some faces just hold the camera. The same expression, so still, five shots in a row, more.

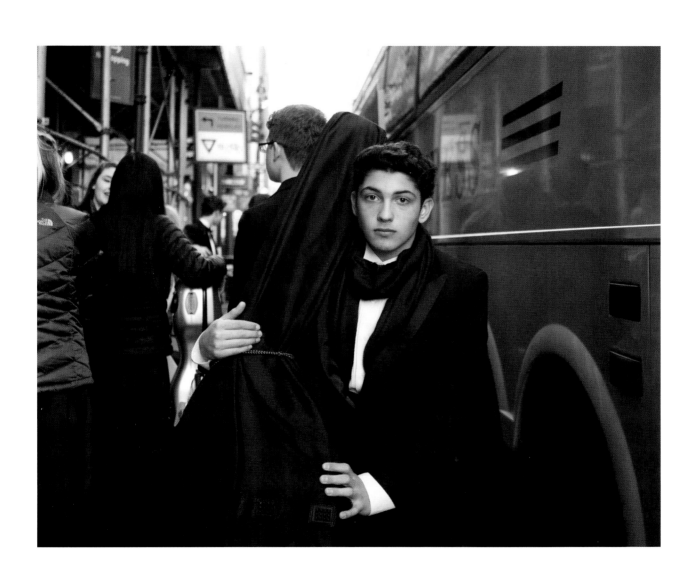

Every time, it's astonishing.

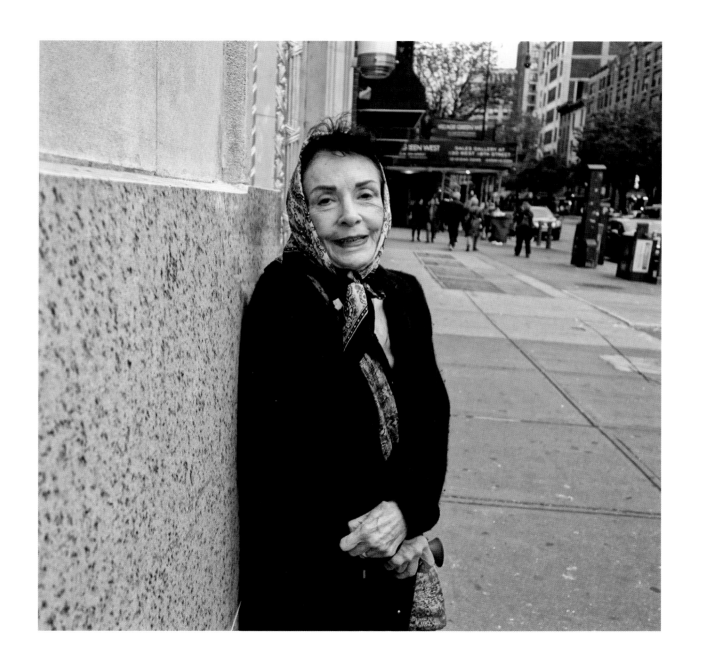

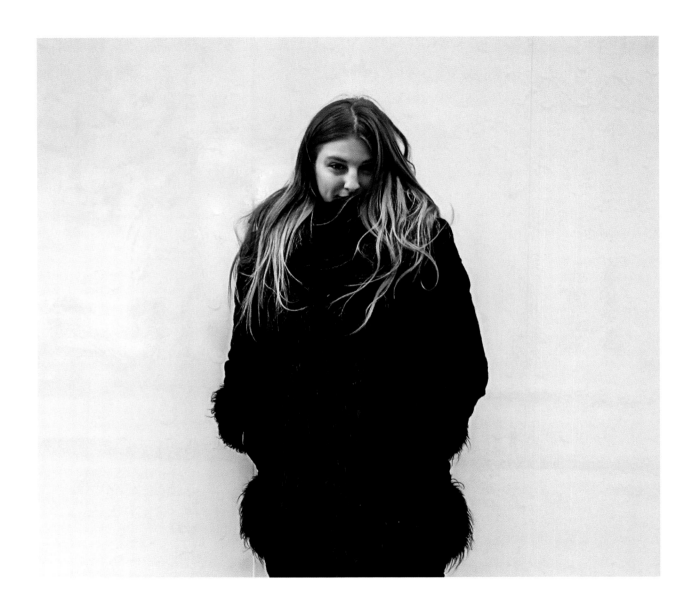

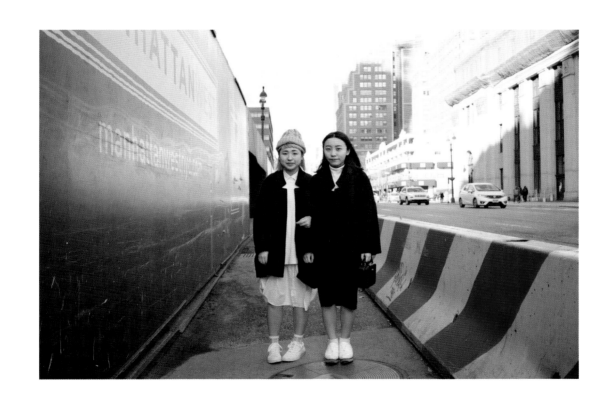

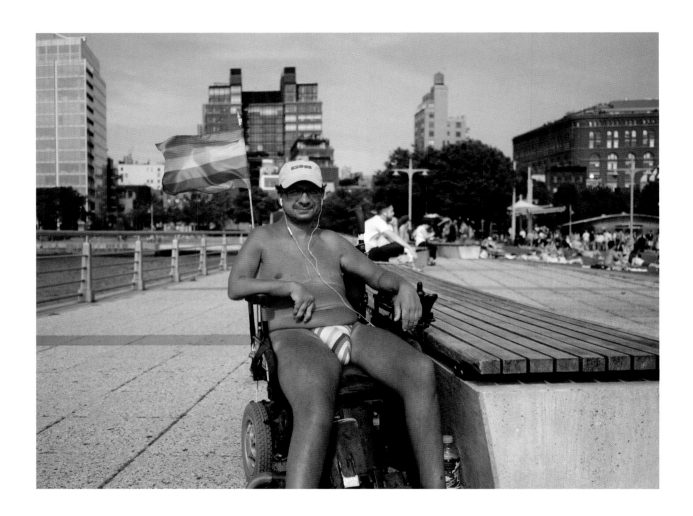

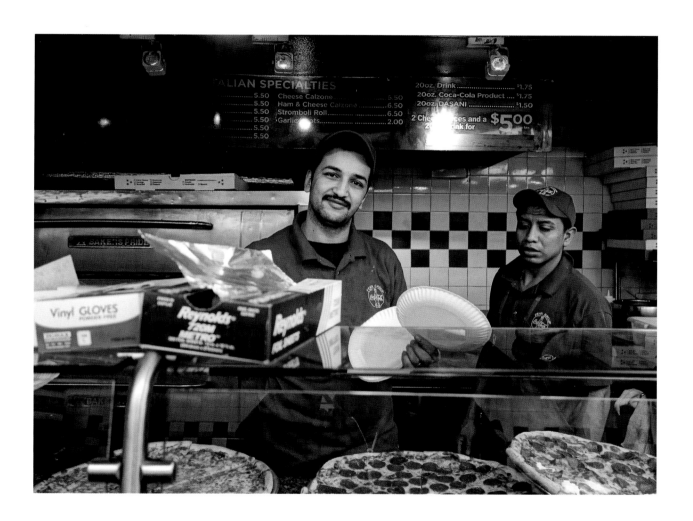

123

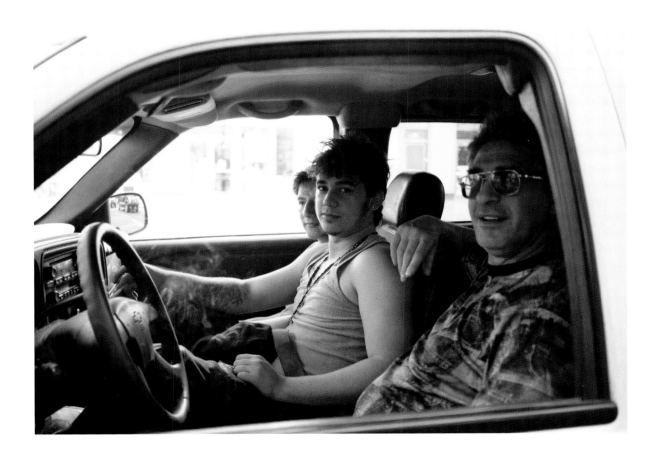

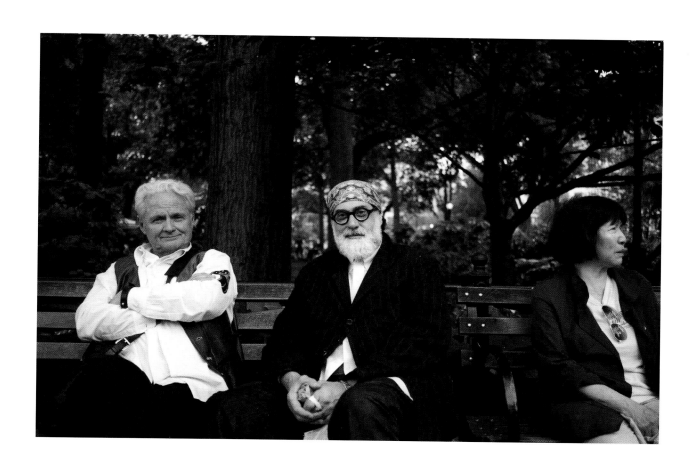

Sometimes people ask why—Why do you want to take my picture?

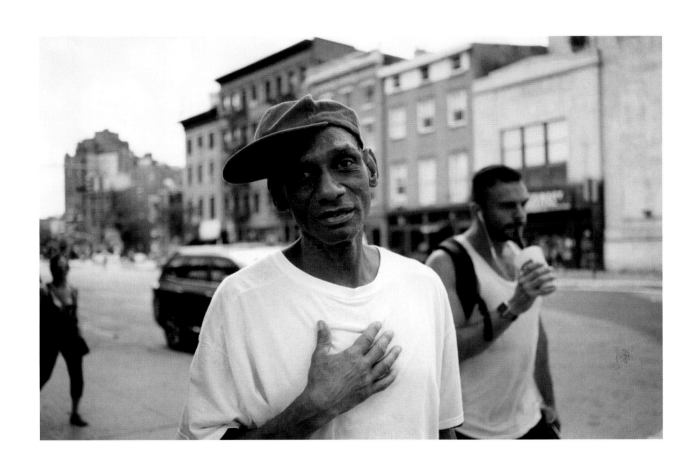

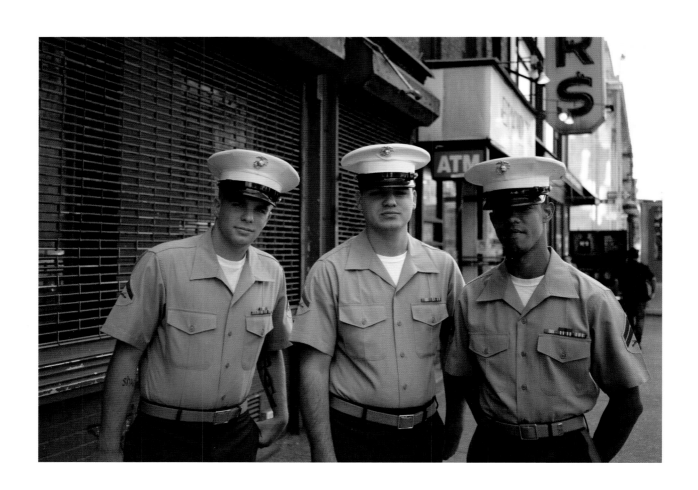

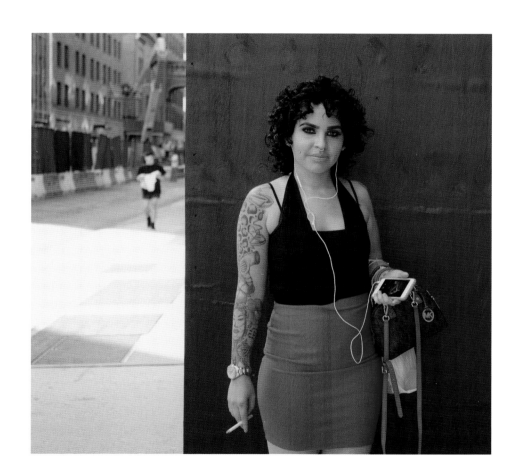

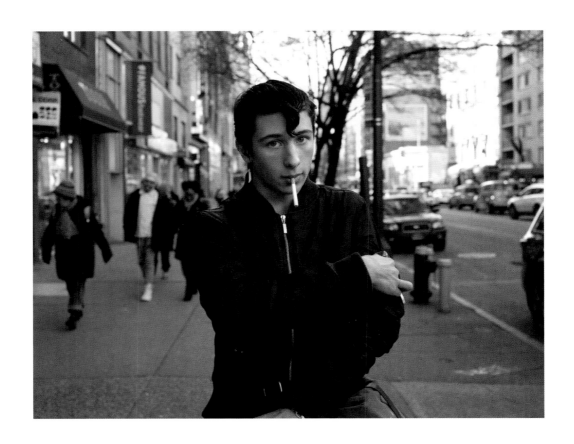

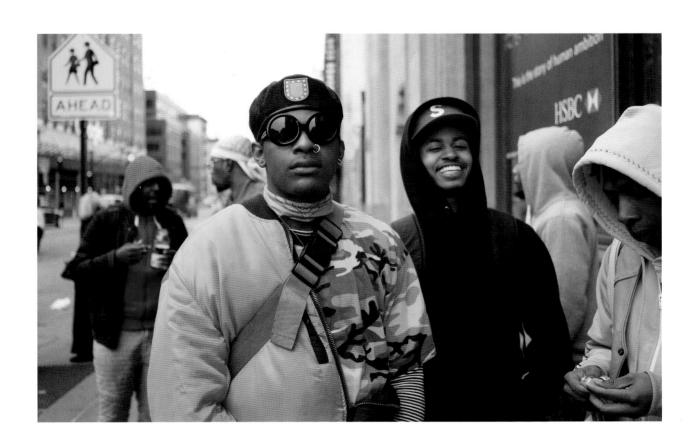

But usually they say nothing, ask for nothing, not even my name. And if they give me theirs, I usually don't remember it.

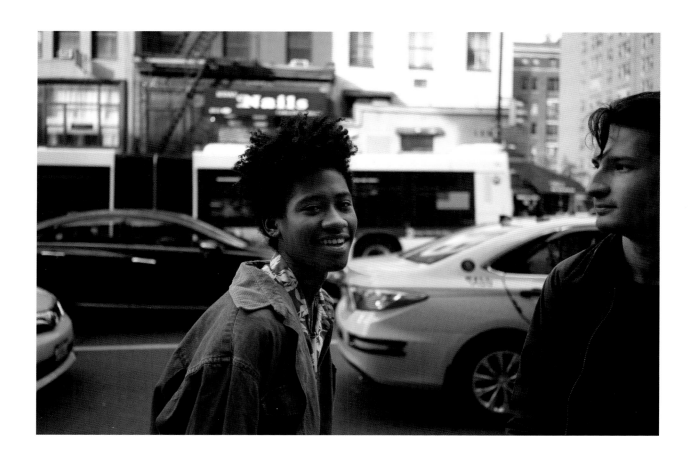

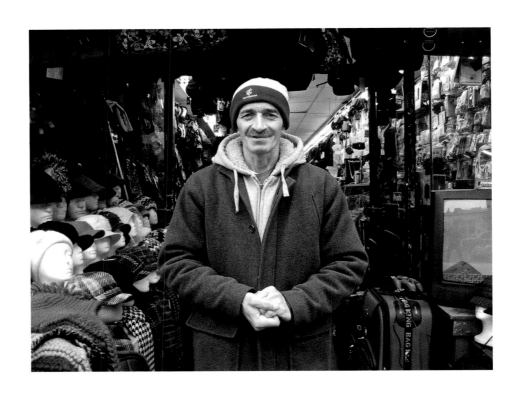

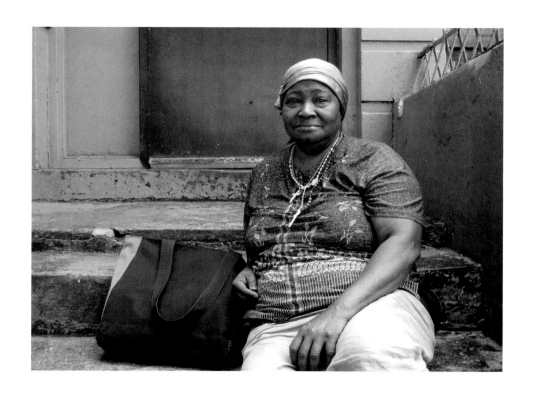

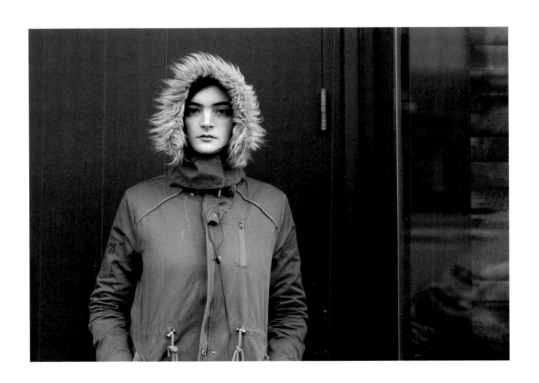

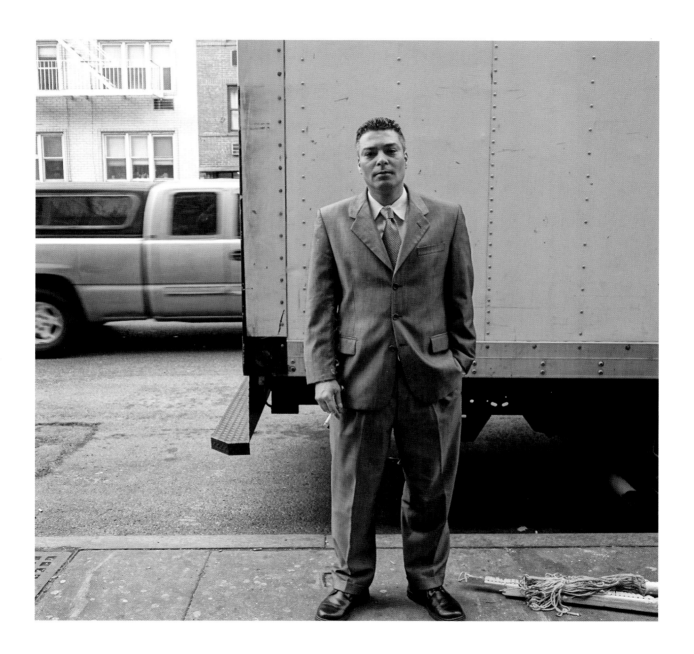

Sometimes I'll see people on the street again and again within a few weeks. Or, a year or two might have passed and I'll still recognize them.

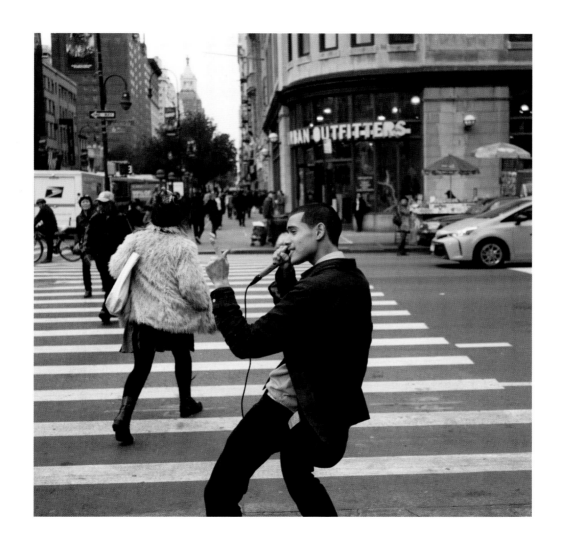

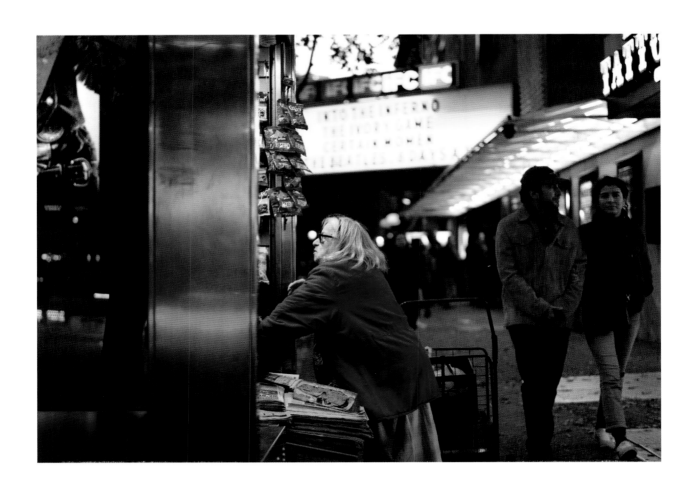

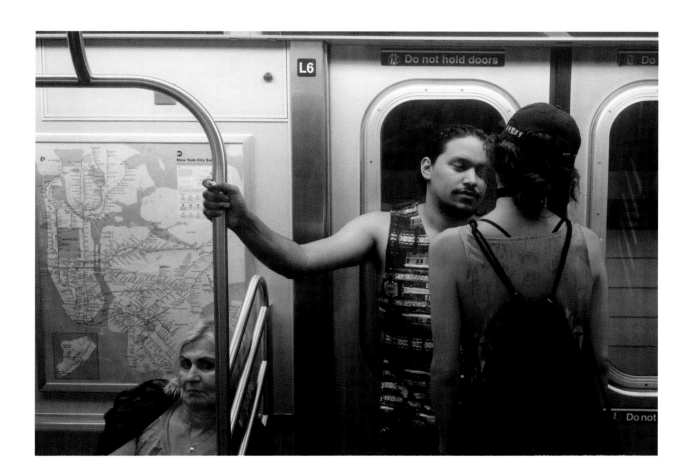

Here in the summer—on the same park bench every night at five.

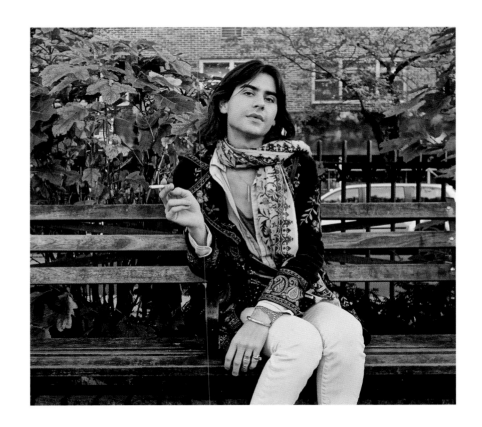

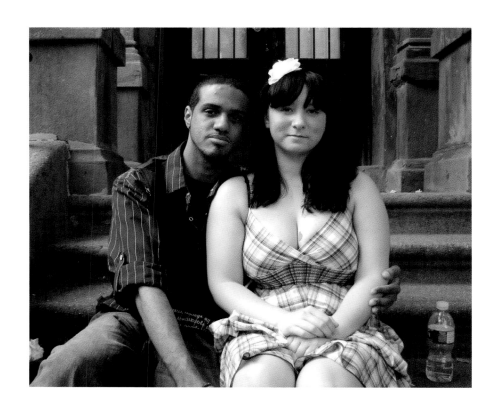

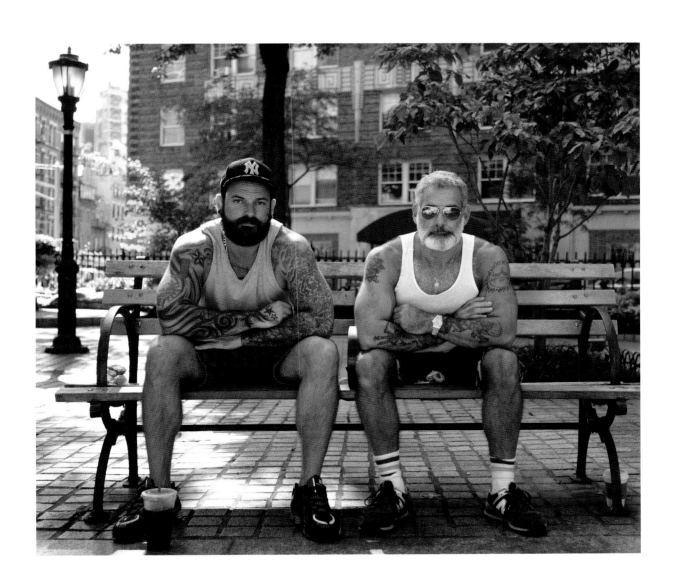

Sometimes they disappear.

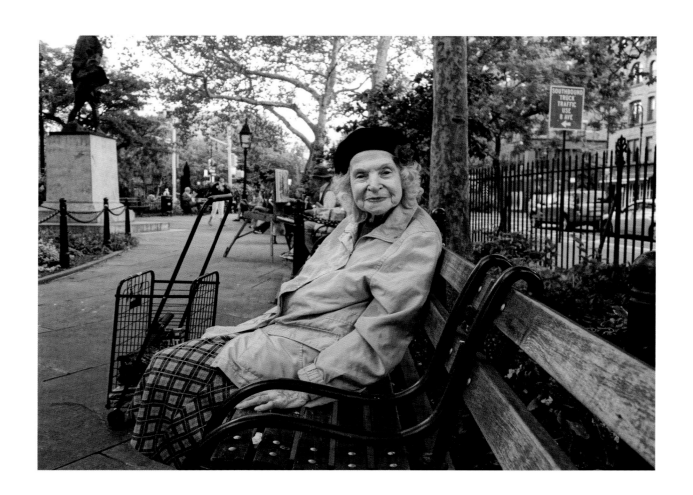

How New York breaks your heart.

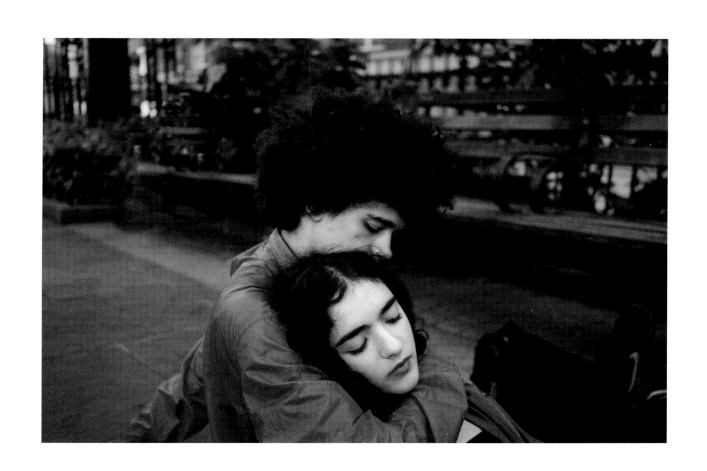

Photographs

Acknowledgments

This book exists largely because of the tremendous support I've received from the entire team at Bloomsbury. In particular, I'd like to acknowledge Emma Hopkin, who sparked the idea for the book, Cindy Loh, Alexandra Pringle, Laura Phillips, Tara Kennedy, Callie Garnett, and especially my editor, Nancy Miller, and creative director Patti Ratchford, who were both a joy to work with and collaborated with me closely.

I'd like to add special thanks to Sasha Wolf, Sandra Phillips, and Frish Brandt for their wise counsel along the way, and to Steven Barclay and Terry Tempest Williams for their encouragement of my work.

I reserve my deepest gratitude for my agent, Emily Forland, to whom this book is dedicated. A writer and photographer could not ask for a better adviser and friend. Finally, thanks again to all the New Yorkers who let me take their picture.

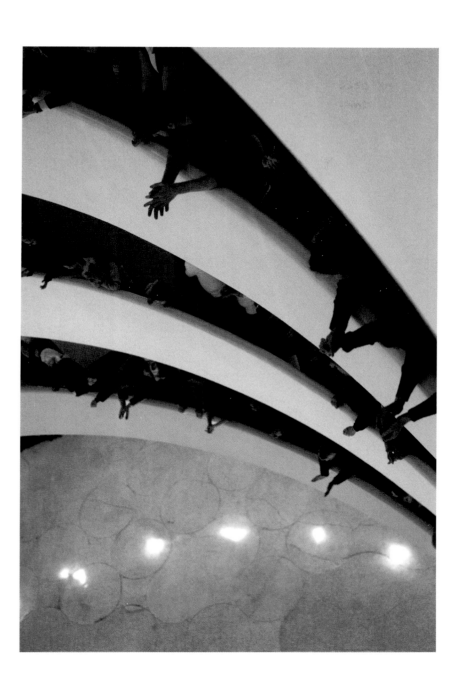

A note on the author

Bill Hayes is the author of *Insomniac City*, *The Anatomist*, *Five Quarts*, and *Sleep Demons*. He is a recipient of a Guggenheim Fellowship in nonfiction and was a visiting scholar at the American Academy in Rome. He is a frequent contributor to the *New York Times*, and his writing has appeared in the *New York Review of Books*, *BuzzFeed*, and the *Guardian*, among other publications. His photographs have been featured in *Vanity Fair*, the *New York Times*, and the *New Yorker*. He lives in New York. Visit his website at billhayes.com.